Books are to be returned on or before
the last date below.

Jasper Johns

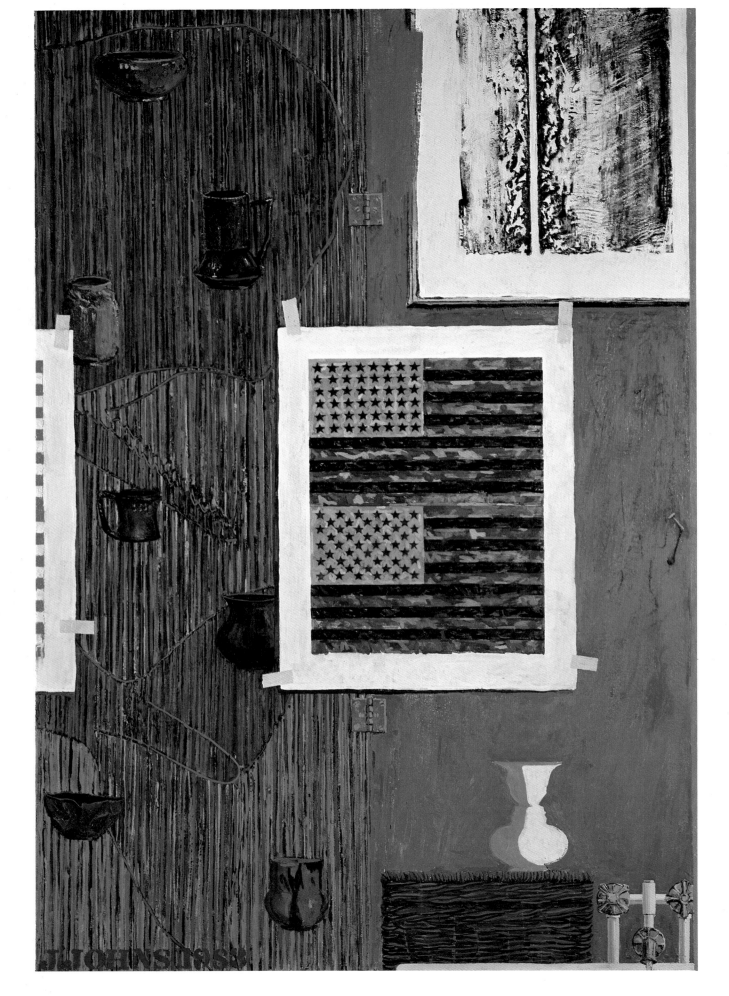

Jasper Johns

Richard Francis

ABBEVILLE PRESS · NEW YORK

Jasper Johns is volume seven in the Modern Masters series.

ACKNOWLEDGMENTS: I am indebted to Jasper Johns, Mark Lancaster, and Leo Castelli; to Richard Chapman; to my editor, Nancy Grubb; but, above all, to Tamar Burchill.

Art director: Howard Morris
Designer: Gerald Pryor
Editor: Nancy Grubb
Production manager: Dana Cole
Picture researcher: Amelia Jones
Chronology, Exhibitions, Public Collections, and Selected Bibliography compiled by Anna Brooke

FRONT COVER: *Target*, 1974. Encaustic and collage on canvas, 16 x 16 in. Museum Moderner Kunst, Vienna; Ludwig Austrian Bequest.

BACK COVER: *Cicada*, 1979. Plate 101.

END PAPERS: Jasper Johns, 1984. Photographs by Mark Lancaster.

FRONTISPIECE: *Ventriloquist*, 1983. Encaustic on canvas, 75 x 50 in. Museum of Fine Arts, Houston. Museum purchase with funds provided by Agnes Cullen Arnold Endowment Fund.

Marginal numbers in the text refer to works illustrated in this volume.

Library of Congress Cataloging in Publication Data
Francis, Richard.
 Jasper Johns.

 (Modern masters series, ISSN 0738-0429; v. 7)
 Bibliography: p.
 Includes index.
 1. Johns, Jasper, 1930– . 2. Artists—United
States—Biography. I. Title. II. Series.
N6537.J6F73 1984 709'.2'4 84-3065
ISBN 0-89659-443-2
ISBN 0-89659-444-0 (pbk.)

First edition

Contents

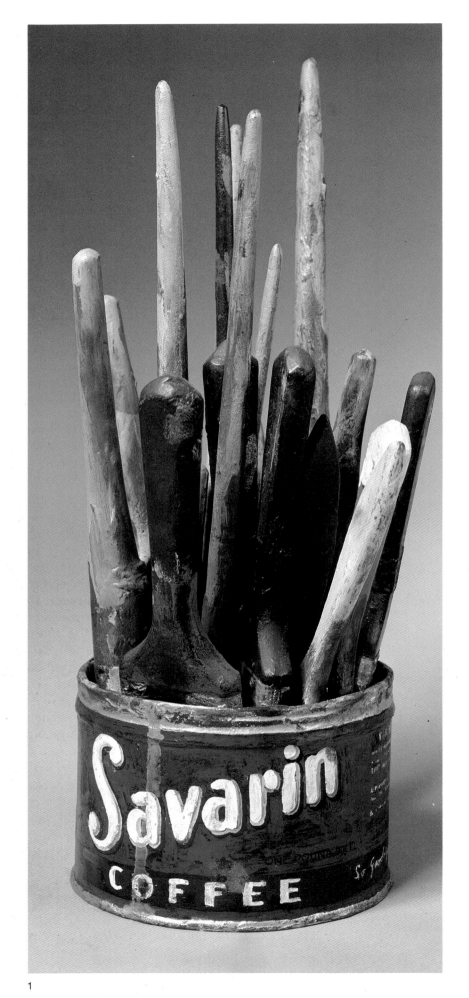

6

1

Introduction

"But the expression of our thoughts can always lie, for we may say one thing and mean another." Imagine the many different things which happen when we say one thing and mean another!—Make the following experiment: say the sentence "It is hot in this room," and mean: "it is cold." Observe closely what you are doing.

We could easily imagine beings who do their private thinking by means of "asides" and who manage their lies by saying one thing aloud, following it up by an aside which says the opposite.

Ludwig Wittgenstein, *The Blue and Brown Books*, 1959

Neither this book nor the work it describes can be considered easy. Jasper Johns's art is generated by complex and difficult ideas, and these cannot be avoided. We are seduced by the objects that Johns chooses to depict, ordinary, everyday things that appear unexpected or absurd as the subjects of this highly abstracted debate. Jasper Johns's art is treacherously difficult to write about. It is subtle, turned in upon itself, and hermetic, and critics are tempted to exaggerate to explain themselves. The allusions in the work are bound together in such a way that cutting the knot that ties them often leaves the critic with an unconnected bunch of ideas in his hands and the mystery still resolutely locked up.

The works are difficult to explain because they deal, often, with the problems specific to making paintings. They are, in that respect, technical, and their vocabulary is that of picture making and comparable with the language of scientific discourse. They are also "modern" in the sense that Clement Greenberg described as modernist. They are part of a discipline "whose characteristic methods" are "to criticize the discipline itself." But modernism had also characteristically discarded objects and representation in favor of an abstracted art. Johns does much to subvert this.

Johns complicates matters by using a few subjects several times and shifting his meaning on each occasion. He refers to the new idea that is his principal concern and backwards to his own earlier uses of the object. He does not work in series; rather he "reproduces" objects or images many times. Each motif carries for him, and ultimately for his viewer, complex meanings. These meanings

1. *Painted Bronze* (Savarin), 1960
Painted bronze, 13½ x 8 in. diameter
Collection of the artist
On loan to Philadelphia Museum of Art

7

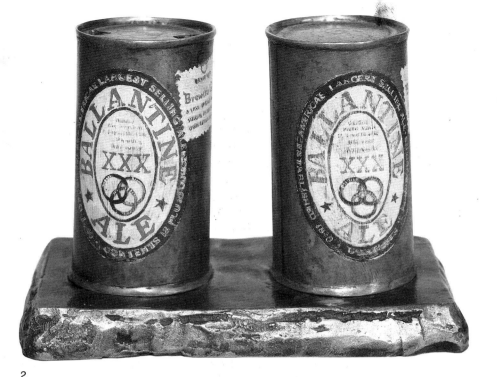

2

are symbolic; they give off signals that are poignant and enigmatic about ideas only recently thought suitable as a subject for art. Donald Kuspit summed it up in 1981. Writing of Johns's recent drawings, he said: "He clings to the overly familiar until it becomes emblematic, a secret code to classified information. Read properly, Johns's images reveal unconscious attitudes about the world that impress themselves on our every recollection of it. In this work, it is not only certain worldly themes that persist, but certain attitudes as well."[1]

The use and reuse of a few ideas is so important to Johns that I will risk working from the particular to the general and trace the use of one image over twenty-two years. First, let us establish Johns's interest in repetition of the image. Christian Geelhaar asked him in an interview about his reuse of objects and images, and Johns replied:

Well perhaps because it interests me I think of it as a complex subject. In part it connects with Duchamp's idea that an artist has only a few ideas and . . . he's probably right . . . one's range is limited by one's interests and imagination and by one's passion . . . but without regard for limitations of that kind, I like to repeat an image in another medium to observe the play between the two: the image and the medium.[2]

In addition to that enjoyable interplay (which Johns admits that others might find boring and repetitious) he has always sought ideas that affect the viewer in more than one way. Irony is a particular weapon employed alongside a banal literalness. The viewer is unbalanced and doubtful about meanings in the work. Johns talks also about "the stress the image takes in different media" and suggests that it is possible to load the object with different meanings so that it works on several levels as the medium and context are changed.

2. *Painted Bronze* (ale cans), 1960
Painted bronze, 5½ x 8 x 4¾ in.
Neue Galerie Ludwig
On loan to Kunstmuseum Basel

3. *Jasper Johns Exhibition Poster for the Whitney Museum*, 1977
Offset, 45¾ x 29¾ in.
Universal Limited Art Editions, West Islip, New York

One of his most familiar images is the Savarin coffee can with brush handles poking out. The *Painted Bronze* (Savarin) of 1960 [1] was carefully made in plaster, cast in bronze, and painted: it is a replica of a coffee can used for brushes in Johns's studio and was produced in the same year as the *Painted Bronze* (ale cans). (The [2] latter was made in response to an aside by Willem de Kooning concerning Johns's dealer, Leo Castelli: "Somebody told me that Bill de Kooning said that you could give that son-of-a-bitch two beer cans and he could sell them. I thought, what a wonderful idea for a sculpture.") Johns later told Michael Crichton: "Doing the ale cans made me see other things around me, so I did the Savarin Can. I think what interested me was the coffee can used to hold turpentine for the brushes—the idea of one thing mixed with another for a purpose."[3] He made it painstakingly well, introducing illusionistic gestures, such as the silvered bronze rim of the tin, only to deny them with a thumbprint in the oil paint of the "can" itself, and offering us a studio still life and a representational sculpture. Johns returned to the Savarin motif in *1st Etchings* (1967–68) and again in the prints and paintings entitled *Decoy* (*Decoy* and *Decoy* [76, 82] *II*, 1971 and 1972). He called it by name in the *Savarin* lithograph [4] that was also the poster for his retrospective at the Whitney Museum of American Art in 1977. It appears in the Monotypes of [3] 1978–79, in a lithograph of 1979–81, in the Monotypes of 1982, [5, 7] and in a recent painting, *Untitled* (1983). [6]

If we were to pursue a few thoughts (by no means exhaustive) about the development of this motif during his career, we might begin to uncover Johns's process of thought.

In the *Painted Bronze*, are we to believe that the brushes have been or are about to be used again?—i.e., are they active tools of the artist's imagination or, more darkly, are they embalmed, both impotent and dead? Does the title *Painted Bronze* increase our uncertainty about the object's status? It is no more than a description of the medium of the work, but it is the title of both this work and the ale cans that preceded it. Johns asks us to recognize the exactitude of the language through the (incomplete) information it conveys: these are indeed painted bronzes, but when calling the works by name rather than looking at them we need to know the brand name to tell them apart. *Painted Bronze* (Savarin) is not the same as *Painted Bronze* (ale cans) or (Ballantine).

In the Monotypes, does the motif become the artist's representation of himself, adopted almost as a self-portrait? Johns alludes specifically in this series to a self-portrait lithograph by Edvard Munch, and the Savarin can occupies the same position as the artist's face in the earlier work. Both Munch and Johns show the arm at the base; Munch draws a skeletal arm, Johns imprints his own arm and adds the initials EM.

Johns's ironic positioning of the image in the center foreground parallels the Munch and offers other, ambiguous readings. It is also as a representative of Johns that it appears as a monochrome image in his most recent work; there it takes its place in relation to other ideas. It comes to stand for Johns's public persona and, by implication, for the corpus of his work as he lays it out in these pieces. What began as a playful manipulation of a joke (the ale

JASPER JOHNS
18 OCTOBER 1977 · 22 JANUARY 1978
WHITNEY MUSEUM
OF AMERICAN ART

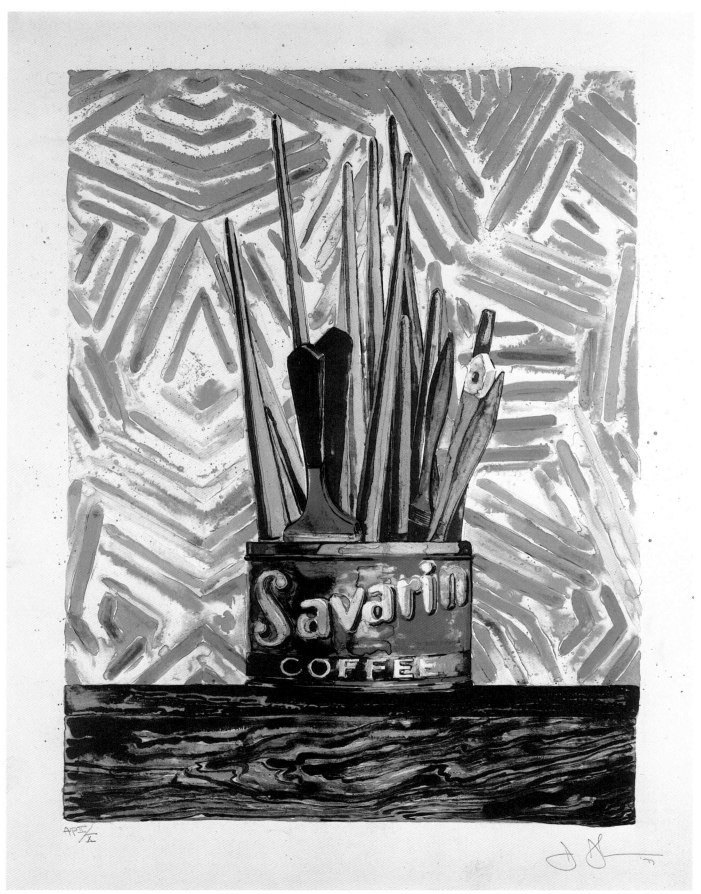

APII/L

4

10

cans) has been transformed first into a critique of sculptural meaning and then, after a long gestation, into an important element of the artist's thought; at each stage its ambiguities have been compounded. Each time that Johns returns to it, he invests it with ideas specific to that period in his development: the "stress" that he talks about is as much here as in technical and formal preoccupations. On each occasion, too, the idea is modified by the beauty of the object.

While Johns has been accused of being a strict rationalist with a penchant for the nostalgic, I believe a clearer description of his work would be the one that T. S. Eliot applied to the wit of the seventeenth-century poet Andrew Marvell: "tough reasonableness beneath the lyric grace." Such wit is an alliance of levity and seriousness (by which the seriousness is intensified); it has a toughness that might be mistaken by the tender-minded for cynicism.

When Leo Steinberg wrote his monograph on Johns in 1962, he generously offered grounds for criticizing it. Acknowledging that his book was subjective, that he had said nothing about the paint-

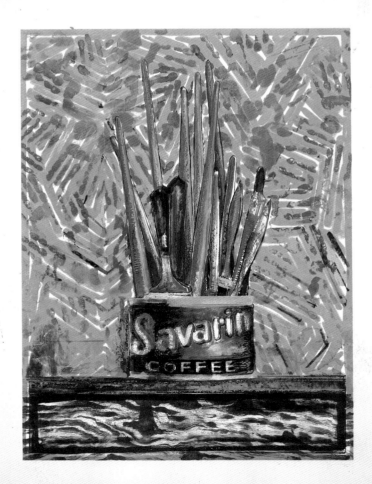

4. *Savarin*, 1977
Lithograph—edition of 50, 45 x 35 in.
Universal Limited Art Editions, West Islip,
New York

5. *Monotype 5*, 1982
Monotype, 45 x 35 in.
Universal Limited Art Editions, West Islip,
New York

5

6

ings as such or that he had reduced them inconclusively to ideas or concepts, he concluded, "He treats Jasper Johns in complete isolation, as if nobody else were painting at all!"[4] All of the above is also true of this book, and it is extraordinary that, more than twenty years after Steinberg, the impulse is still to write about the work in isolation. The work appears to demand an exclusive attention and so is set apart from other works of a similar date. But if the works themselves are exclusive, their effects have been multifarious. It is commonplace now to regard Johns as having had enormous influence over the last thirty years, and it may be worth pausing to consider some of the consequences of this.

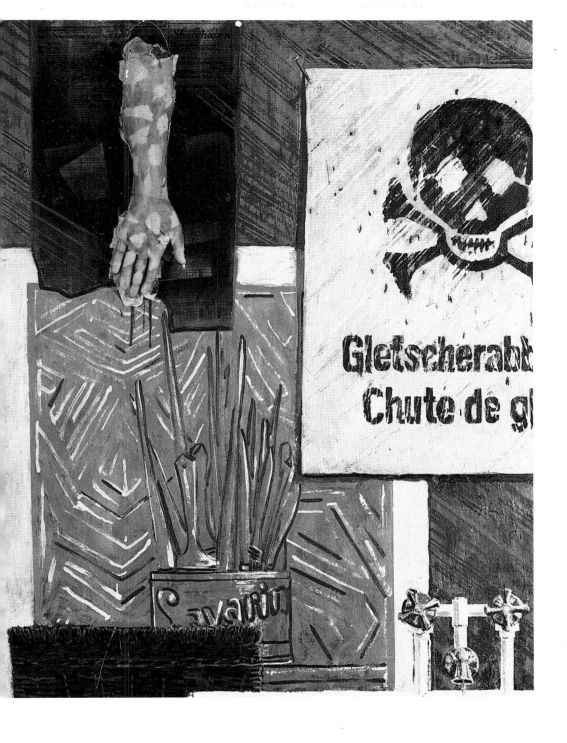

6. *Untitled*, 1983
Encaustic and collage on canvas with objects,
48⅛ x 75⅛ in.
Mr. and Mrs. S. I. Newhouse, Jr.

Johns's peers are those artists born in the 1920s and '30s who have also changed the history of American art: Ellsworth Kelly, Robert Rauschenberg, Claes Oldenburg, and Andy Warhol. Collectively (except Kelly, who was heavily imbued with European experience), they were labeled "Pop artists," a term invented by critics to provide a useful catchall for superficially similar work in both the United States and England. Pop was a helpful invention, but its concentration on the nonart content of the works was detrimental to a real understanding of the motives of the artists. It may be easier to reconcile this view with the British artists, whose discussions included cultural historians, designers, and architects,

but the Americans themselves seem isolated. It is true that they met and talked, but I suspect without the same proselytizing intentions.

Johns and his contemporaries were concerned with tackling the problems set out for them by the preceding generation, the Abstract Expressionists. Pollock had died in 1956, and we have only to recall that when Johns was looking for a gallery the following year he was anxious to find a neutral space, that is, one not infected by the second Abstract Expressionist generation. The weight of this generation would have fallen particularly heavily on the younger artists at a time when the Abstract Expressionists were being promoted extensively, at home and abroad, as the "true" American artists. Additionally, Abstract Expressionism had accrued a critical vocabulary and eminent apologists, such as Clement Greenberg and Harold Rosenberg, who regarded it as the true heir of modern art proper and the flagbearer for modernism. Abstract Expressionism and modernism became synonymous.

Johns's entry into this arena with his Flag and Target paintings signaled, for some, the end of the Abstract Expressionist stranglehold. He has put it another way. When talking to Peter Fuller in 1978, he denied that Abstract Expressionism had been looking tired and said: "Any ism will expire. By having an ism you are separating it from other things. Your attention has to deal with the entire field. Things displace one another in one's interest."[5] The relative neutrality of the Flags and Targets, their acknowledgment of sources outside art was iconoclastic. They caused a rupture in critical thinking, and Greenberg even wrote:"Everything that used to serve representation and illusion is left to serve nothing but itself, that is abstraction; while everything that usually connotes the abstract or decorative—flatness, bare outlines, all over or symmetrical design is put to the service of representation."[6]

What Johns and Rauschenberg had done was to make possible the use in art of materials and objects from outside the art world—sometimes from popular culture, sometimes from a general culture—and mediated them in such a way that art became implicit in them. They were not representing the world nor creating visual equivalents of their own emotions but rather offering a complex and messy restatement of particular aesthetic problems. They also acknowledged fully the psychological and rational processes that art could deal with alongside the emotional and the formal. This complexity was allied to images that, in Johns's case, triggered a specifically American response.

All the things that Johns made were objects—they have the quality of a thing when you see them, not necessarily an art object but closer usually to something in the world around us and offering a robust answer to our questions about its nature. These things repose on the gallery wall with a substantial ability to transform the materials they are made from. This mute, real quality, so different from the objecthood sought by post-painterly abstractionists, was the generator for substantial areas of art that followed. What became known as the "art of the real," a title used in a Museum of Modern Art touring exhibition, took up the simply divided forms and the straightforward sculptural shapes that Johns and the others had produced.

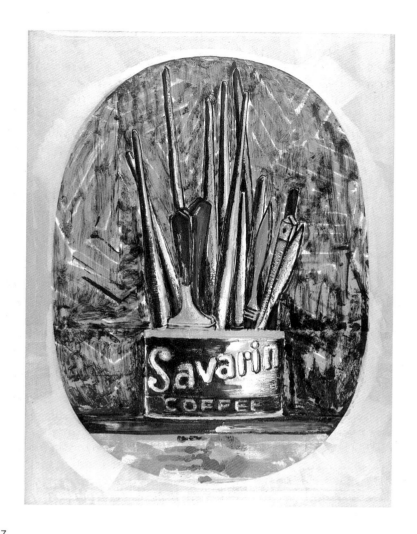

7

Artists of an equivalent age—such as Carl Andre (b. 1935) and Sol LeWitt (b. 1928)—pursued another aspect, that of the conceptual propositions suggested by Johns's work. Their analyses produced simple, multipart works with a strongly serial or formal basis. These inventions relied heavily on the gallery space as the framing element of the work and often brought objects or elements previously disregarded—e.g., metal plates or fire bricks—into the art space, or used the wall of the gallery as the support for drawings of a highly organized formal structure. This segment of Johns's work has, arguably, been the most influential, and even so, it has taken several years to absorb its implications.

Johns's more recent work is regarded as outside the current "new painting" canon; yet the artists he has looked at recently are those that have been of interest to the "new" artists (Georg Baselitz, like Johns, has taken Munch's *Between the Clock and the Bed* as a subject for one of his own works), and his work contains as many references to psychological traumas as theirs. Moreover, it does so with a strong control of the means at its disposal, a reticence and

108

7. *Monotype 7*, 1982
Monotype, 45 x 35 in.
Universal Limited Art Editions, West Islip,
New York

an avoidance of bravura display for its own sake.

Johns recently bought from the Library of Congress a copy of a Walker Evans photograph showing a brick wall covered with posters of the Silas Green show from New Orleans, a Negro cabaret group that performed in the South during the 1930s. Johns has colored the print in faded reds and greens, the colors he recalls when he saw the posters as a child. He says that the dance troupe is the only exciting and glamorous thing that he remembers from his childhood.

Jasper Johns was born on May 15, 1930, in Augusta, Georgia, and his parents separated soon after he was born. John Cage gives this poignant description:

His earliest memories concern living with his grandparents in Allendale, South Carolina. Later, in the same town, he lived with an aunt and an uncle who had twins, a brother and a sister. Then he went back to live with his grandparents. After the third grade at school he went to Columbia, which seemed like a big city, to live with his mother and stepfather. A year later, school finished, he went to a community on a lake called The Corner to stay with his Aunt Gladys. . . . He stayed there for six years studying with his aunt who taught all the grades in one room, a school called Climax. The following year he finished high school living in Sumter with his mother and stepfather, two half sisters and his half brother. He went to college for a year and a half in Columbia where he lived alone. He made two visits during that period, one to his father, one to his mother. Leaving college he came to New York. . . .[7]

This period in Johns's life was and remains of crucial importance to him. Peter Fuller asked him in 1978 why he disliked talking about his early life, and he replied, "It wasn't specially cheerful." Fuller continued: "Henry Moore once said that art was invariably an attempt to regain the intensity of earliest experience. Do you think that?" To this Johns replied: "I certainly believe that everything I do is attached to my childhood, but I would not make the statement that you just said he had made."[8]

Johns spent six months in Japan on military service (1951) and this has had a profound influence upon him. He has returned to Japanese subject matter regularly and is an avid reader of Japanese literature (in translation) and history. In 1953, a year after his move to New York, Johns resolved to stop "becoming an artist and to be an artist" and marked the occasion by destroying most of his earlier work. He lived for a period in the same building as Robert Rauschenberg. They shared many ideas: Rauschenberg was older, more extrovert, and the first "devoted painter" that Johns had met. Rauschenberg has said that this mutual encouragement was crucial in a period when their work went unnoticed and they supported themselves with odd jobs such as dressing windows for Tiffany and other New York stores.

Johns has always remained an intensely private person who has sought solitude to work in a series of houses in and out of New York City. Currently he lives in a small converted farmhouse and barn in wooded seclusion about an hour from Manhattan and has a house on a Caribbean island. Johns's closest friends are not his peers; often they are not artists, but writers, musicians, and dancers.

8

One of his longest friendships is with John Cage and, via Cage, with the dancer-choreographer Merce Cunningham. Cage has had a particular influence on Johns's ways of thinking; some of Cage's attitudes and some of his methods of deflecting attention have been adopted by Johns. The use of the world outside art as part of art and the repetition of motifs in musical notation have interested them both. For several years, Johns had a close collaboration with Merce Cunningham as artistic advisor to Cunningham's Dance Company. This offered him not only the opportunity to design costumes and sets for relatively abstract dance, but also something that is of importance to him: the need to think in terms of three dimensions and time. (He talks, for instance, of the recent painting *Dancers on a Plane*, 1980, which is "about" Cunningham and the resolution of this problem.) 102

Johns uses jokes as a way of diverting attention from himself or his opinions. He has originated a style of conversation that deflects the questioner precisely and with great charm, a conversation that deals with philosophical questions in terms of the everyday. Here, for example, he is talking about *Dancers on a Plane* and answering a question about the reintroduction of defined subject matter into his recent works. After a twenty-second pause he replies:

Often one draws from things that one knows in working . . . and one works—I don't know what it's called—you see something but do something else, but, in your head, what you're doing has a relationship to something you're seeing. It's not . . . you can say it's very important or it's not important at all. Often, it's not something you want to point to—to say. You don't want to say I get here by examining that, by drawing conclusions from that, because then it suggests that you're making a picture of that, you can make a better picture of that, copying it a little more carefully or something. Still the mind often works that way using something and making something unlike it and occasionally one wants to say what one is doing. . . .

Q: You want to say, not see.

Say. I don't, one does not want to be misleading, unless that's what one wants to do. . . . But one does not always want to be misleading and occasionally one wants to recognize that one is tied to certain procedures, certain ways of thinking, or not, forms of inspiration (that sounds too grand) but one often draws conclusions from one's experiences, and makes something. And I think that that kind of pointing in that way is simply an attempt to include that—just to recognize it, really.

Q: That pointing is something specific and cultural and it happens in the work for only a relatively short time.

Well, if you did it all the time you would only be pointing backwards and you don't want to do that because really your work doesn't work, at its best, does not have a direction I don't think. It's just there.[9]

8. Jasper Johns at Simca Print Artists, New York, 1976
Photograph by Hans Namuth

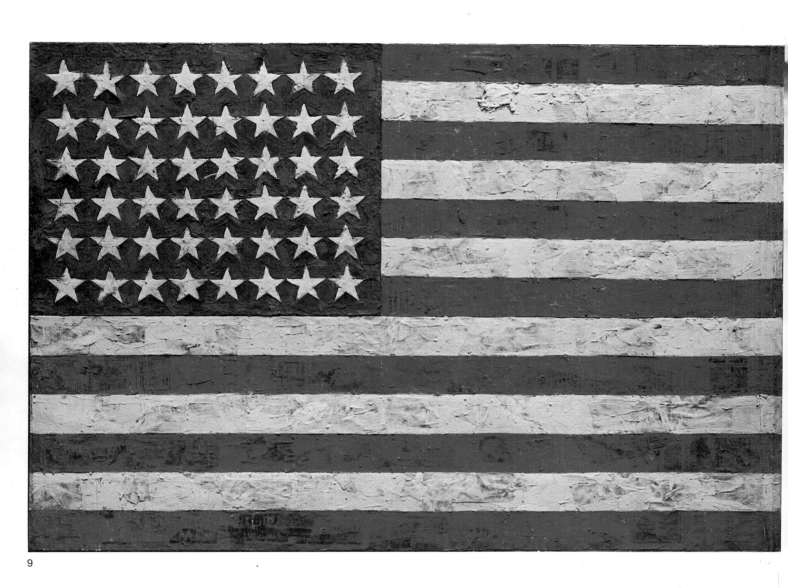

9

Up to, and Including, "According to What," 1954–1964

Johns's first work in a museum exhibition was *Green Target* (1955), shown in *Artists of the New York School: Second Generation* at the Jewish Museum in 1957. The dealer Leo Castelli, who had only recently opened his own gallery, had seen the work and mentioned it while visiting Rauschenberg, who took him downstairs to meet Johns. Castelli included two works by Johns in a group show the same year and gave him a one-man show in January 1958. From this exhibition Alfred Barr bought three works for the Museum of Modern Art, and major collectors bought others. This immediate success was highly contentious, but within a year Johns was well known internationally and soon moved into that band of contemporary artists who have to deal with the pressures of celebrity.

Castelli's exhibition of Johns's work in his gallery in 1958 was drawn from that "fully formed body of work" the dealer had been so astounded to find in the studio. Few people except artists could have known about it, and its popular success had perhaps more to do with the subject matter and its reproducibility in magazines than with a widespread understanding of the art itself. The Flags, Targets, Alphabets, and Numbers were remarkable also for the fact that they had apparently come out of nowhere. Johns has denied any influence from art historical sources, knew very few of his contemporaries, and says that he had not yet "organized any thinking, any of my own thinking, so that I don't think other people's thinking was very interesting to me!"[10]

Johns does seem to have reacted to criticism of his earlier work, however. These compartmented collages had been compared to the work of Kurt Schwitters, and it was after he had looked at Schwitters's work at firsthand that Johns destroyed his earlier work. (Those that remain were already in other people's possession.) The denial of an earlier phase after critical approval or disapproval and a subsequent rupture occur several times in Johns's career. The earlier work revealed too much of his emotional responses, and he now sought to hide this. He began to look around him for a given subject matter that would enable him to concentrate on making an object or a replica of another object. Ironically,

9. *Flag*, 1954–55
Encaustic, oil, and collage on fabric mounted on plywood, 42¼ x 60⅝ in.
The Museum of Modern Art, New York
Gift of Philip Johnson

these objects have become so closely associated with him that they are now "his" subjects.

The image of the flag came to Johns in a dream. "Using the design of the American flag took care of a great deal for me because I didn't have to design it. So I went on to similar things like the targets—things the mind already knows. That gives me room to work on other levels."[11] Johns's insistence on his minimal conscious interference with his subject matter—which comes from his unconscious—directs us primarily to the way the works are made. Little has been written about Johns's use of dream or other unconscious imagery. The use of dream images is associated with Surrealist, Symbolist, and Abstract Expressionist art, not with the highly structured formal art that Johns appeared to be making in the mid-1950s. At that time Johns was still employing the collage techniques that he used in 1954. He was now using encaustic, a method of painting with liquid wax in which pigment is dissolved. He first laid down, embedded in wax, a collage of newspaper scraps and sometimes photographs. These usually have the same general structure as the image that is painted on top of them— concentric circles for Targets, etc.—and often show through the final layer. Johns enjoyed using the encaustic technique. Because it hardened rapidly, he could work very quickly and see the process

11

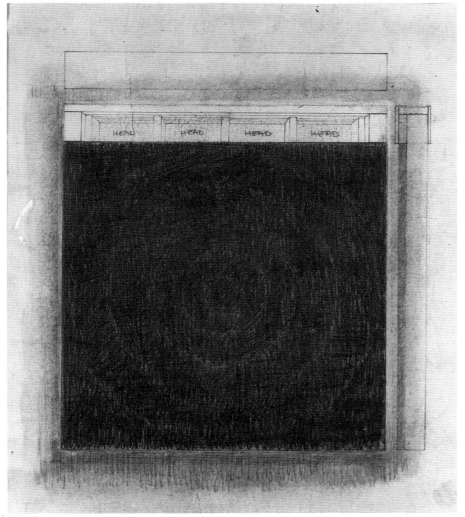

10. *Target with Four Faces*, 1955
Pencil on paper, 8½ x 7¼ in.
Collection of the artist

11. Jasper Johns in his New York studio, 1955
Photograph by Robert Rauschenberg

of working; oil paint, by contrast, dries slowly and additional strokes smear or hide the lower layers. The result of his use of encaustic was a beautiful, translucent surface bearing the record of its own making, a surface whose qualities of quiet, controlled structure contrasted strongly with the highly emotional violence of Abstract Expressionist surfaces.

But Johns's concern was not only with making: his "untrained mind" had sensed some other characteristics of the flag and target: they were essentially invisible or rather, because they were familiar, "seen and not looked at." Johns's art was in opposition to the emotional and the expressive, and he concurrently argued for a more thoughtful, intellectual approach to painting. Johns was eager to disprove Duchamp's charge that painters were stupid: "bête comme un peintre." Johns was seeking in his work a neutrality, a "cool" quality (in Marshall McLuhan's then fashionable vocabulary) that would enable him to concentrate on other aspects of the thing. In an interview with David Sylvester he described the Flags, Targets, Letters, and Numbers of these years as "pre-formed, conventional, de-personalised, factual, exterior elements," and when asked about the attraction (i.e., the meaning) of the depersonalized, replied: "I'm interested in things which suggest the world rather than suggest the personality. I'm interested in things which suggest things which *are* rather than in judgments. The most conventional things, the most ordinary things—it seems to me that those things can be dealt with without having to judge them; they seem to me to exist as clear facts not involving aesthetic hierarchy."[12]

Part of Johns's sketchbook notes were published in *Art and Literature* in 1965, and one section illuminates his further concerns with the object. He wrote:

Take an object
Do something to it
Do something else to it
" " " " "

Take a canvas.
Put a mark on it.
Put another mark on it.
" " " " "

Make something
Find a use for it

AND/OR
Invent a function
Find an object.[13]

These notes are strongly reminiscent of Duchamp's notes for the *Large Glass*; they are instructions in words for work to be undertaken. Johns and Duchamp are both concerned with language, with its precisions (and imprecisions), and this lends a particular quality to the art. It is not a literary but an analytical stance. Johns first outlines a working method that gives equal status to object and canvas; you take them and do something to them. The object and the art object are made and modified in the same way. Art and life are created by similar processes. But he goes farther; he links the use of the object to its making and the finding of an object to

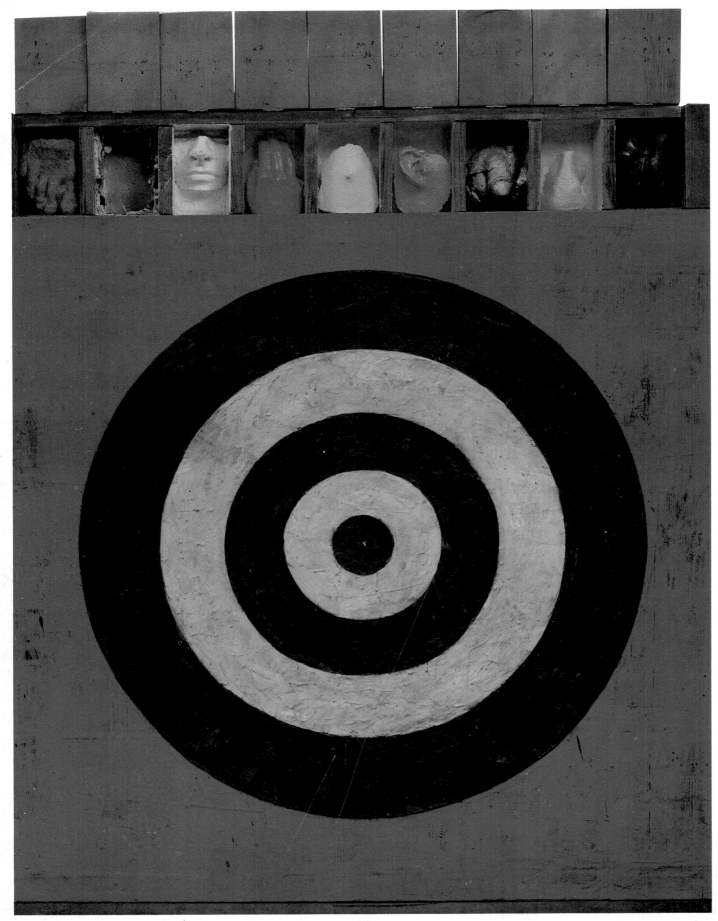

12. *Target with Plaster Casts*, 1955
Encaustic and collage on canvas with plaster
casts, 51 x 44 x 3½ in.
Mr. and Mrs. Leo Castelli

13. *Green Target*, 1955
Encaustic on newspaper over canvas,
60 x 60 in.
The Museum of Modern Art, New York
Richard S. Zeisler Fund

14. *Tango*, 1955
Encaustic and collage on canvas with objects,
43 x 55 in.
Private collection, Germany

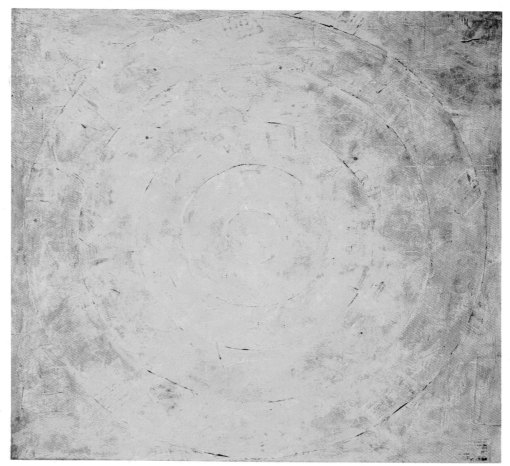

13

14

its function. He dissolves the traditional distinction between art objects and everyday objects. A function may be suggested for a useless art object (Johns's *Shade*, 1959, is a painted blind covering a canvas and, by implication, a window); the useful thing may be given an invented art function. Function and use are woven together and become the same. Johns's questions went to the core of the problem that modern artists faced. The making of an art object that referred to itself gave it a high status in art's terms but in no other. Johns had subverted those formal preoccupations and placed his objects nearer to the world outside art. In doing so he was provoking questions about the nature and use of the object in its conventional role.

That is why the flag was such a potent image. True, it was flat and could be represented as a two-dimensional surface, but most of all it was a symbol of the American nation. When Johns fixed it flat in wax, its use changed to that of a painting; it carried different connotations. Although Johns worked instinctively, he said: "But instinct tends to become doctrine. But the thing has certainly not been reasoned in this way before beginning; they have simply been begun."[14] This insistent preoccupation with the everyday is characteristic: from it he creates, in the way that young children do, an imagined world where the objects become special and magical.

With the target Johns found a less-defined subject; a target is not specific to any country, its colors may change and its function is singular (to be shot at). A target is formally closer to a painting than a flag. You would expect to hang it or stand it up, you would use it by shooting at it, it did not symbolize anything specific. Its dispersion on the plane, in contrast to the flag, was continuous. The field cannot be subdivided into rectangular portions: the circles are concentric and centered. Johns made several versions of this image. Its lack of specificity and its alloverness (Kenneth Noland was to make this part of it the subject of a large number of his works) left Johns free to add an emotional charge outside the cool image. On two occasions in the mid-1950s he supplied this psychological load with plaster casts. He had made a work in 1953 that incorporated the plaster cast of a head, and he had continued to make and store casts; also in 1953 he had made a work with lidded compartments. Now, in 1955, he took a group of these casts, painted them in monochromatic contrasting colors, and arranged them in boxes attached to the top of a target painting. He emphasized that the painting was a substantial object by fixing a thick batten to the bottom and painting the edges of the canvas. The work demands from the viewer an act of voyeurism, that is lifting the flaps to reveal the parts inside. Since they are human, these parts—some "private" in the conventional definition, all private in this context—suggest an emotional quality at odds with the "cool" target below them. Johns seeks to deny the importance of this emotional content (or at least his enclosure of the casts is an attempt to deny access and thus prevent us from giving his work these meanings). In *Target with Four Faces* the human presence is unmistakable, but cut off and forced into the boxes. A part of the face is more poignant than the whole, but Johns excused himself

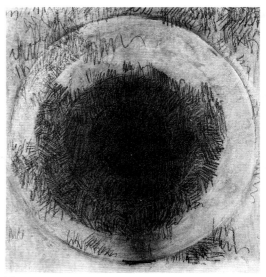

15

16

by saying, "They couldn't have fitted into the boxes if I'd left them whole," and he is reported to have rearranged them to exclude a sequential reading that would have suggested the mouth was about to speak.[15] He would like us to infer that these are objects of no aesthetic or personal importance; we might doubt this from looking at the use to which Johns puts casts in his later work. Casting becomes a way of making parts of his personal experience "real" and gives him the chance to lay this against his more formal concerns.

Johns has described, for example, how he intended in *Target* [12] *with Plaster Casts* to have musical notes played by lifting the hinged doors, and that the casts were substituted later. This mechanical arrangement is also apparent in another painting of 1955, *Tango*, where the spectator is asked to make the work play [14] by turning a key protruding from the face of the canvas. Johns wrote: "I wanted to suggest a physical relationship to the pictures that was active. In the targets one could stand back or one might go very close and lift the lids and shut them. In *Tango* to wind the key and hear the sound you had to stand relatively close to the painting, too close to see the outside shape of the picture."[16] Johns was arguing against the prevailing aesthetic but in a subtle and ironic way. The spectator is emotionally entrapped in the Targets by actively taking part in the mechanism of the picture's display—viewing becomes voyeurism. The formal device of enveloping the spectator within the field of a large canvas, which was favored by many artists of this period, is accomplished in the relatively small *Tango* (43 x 55 in.) by the mechanical musical box. Johns imposes conditions upon his viewer; he excites an emotional response with the excuse that he is asking a formal question. He also suggests, ironically, that the work is from an Action Painter's hand by leaving the bottom edge unpainted, an accident that he decided to exploit; this, of course, reinforces his assertion of the painterliness of the work, of its function as a painting.

The other works of the 1950s in which Johns took up mainly formal and thereby perceptual arguments are the Flags on larger

'All over' painting of 46 Ex
derived by required proximity to
work, despite initial appearnce

15. *Target*, 1958
Black conté on paper, 15½ x 15 in.
Denise and Andrew Saul

16. *Flag*, 1957
Pencil on paper, 10⅞ x 15⁵⁄₁₆ in.
Collection of the artist

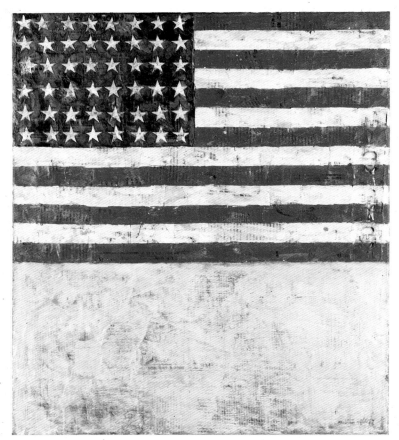

17

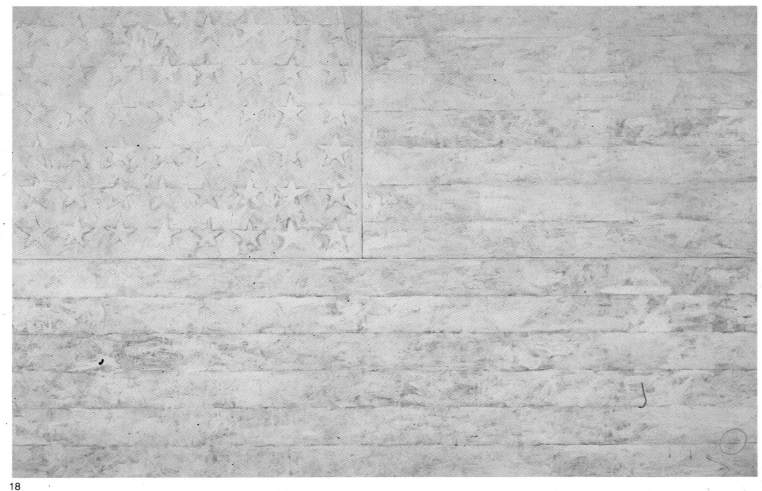

18

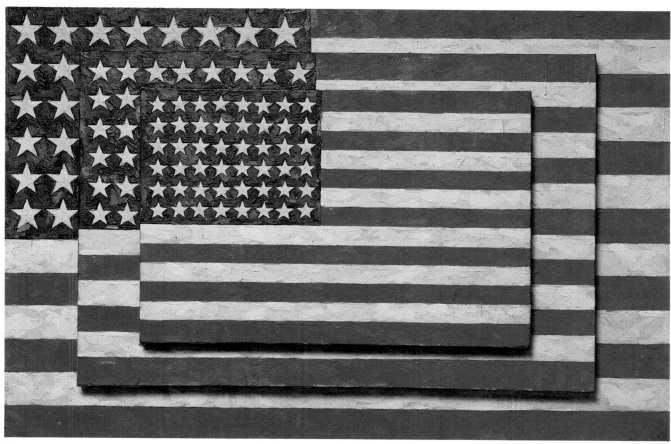

19

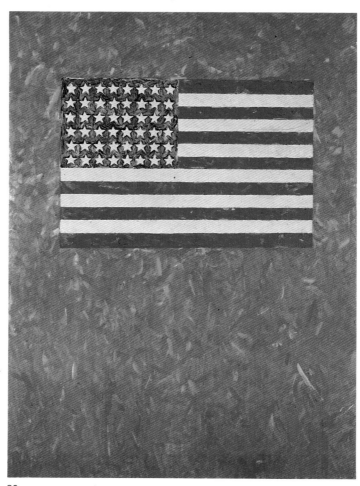

17. *Flag above White with Collage*, 1955
Encaustic and collage on canvas,
22½ x 19¼ in.
Collection of the artist
On loan to Kunstmuseum Basel

18. *White Flag*, 1955
Encaustic and collage on canvas,
78⅝ x 120¾ in.
Collection of the artist
On loan to Yale University Art Gallery,
New Haven

19. *Three Flags*, 1958
Encaustic on canvas, 30⅞ x 45½ x 5 in.
Whitney Museum of American Art, New York
50th Anniversary Gift of the Gilman
Foundation, Inc., the Lauder Foundation, and
the Painting and Sculpture Committee

20. *Flag on Orange Field*, 1957
Encaustic on canvas, 66 x 49 in.
Museum Ludwig, Cologne

20

21

fields of color and in single colors. In *Flag above White with Collage*
(1955) and *Flag on Orange Field* (1957) the flag is only a part of
the whole image and Johns is thus using a conventional figure-
ground relationship. He has called this an extension of the surface
"beyond the subject matter—or what most people would call the
subject matter." By giving the ground and the subject equal im-
portance he reinforces the irony of taking a subject—the flag—that
is "not looked at." *Flag on Orange Field* might also refer to the
notion of a painted field in Impressionist painting, emphasizing
that Johns's roots lie there. The same is true of the *White Flag*,
the largest work of these years, where the shimmering surface
resembles a Monet and where the subject is submerged in the way
that this monochromatic painting is made.

Perhaps Johns turned his attention to Cubism when in *Three
Flags* (1958) he further questioned the idea of the picture plane.
The object that he created superimposes three painted images of
the flag, with each successively smaller flag obliterating part of
the one beneath. The object that results is an amalgam of painting
and sculpture. He has painted flat images (the flag), but the picture
plane cannot be defined. Is it the largest canvas and do the others
project; is it the smallest with the others receding? This concern
with the plane recurs throughout his career; in later works the
clues are more subtle and the surface is not broken. Most recently
he has used clues directly from the Cubist vocabulary; in *Three
Flags* the idea is still abstracted and formal, and may also be a
comment on the integrity of the surface in the paintings of his
peers such as Noland and Kelly. We could incidentally speculate
on further repetition: three is conventionally regarded as the first
number in a mathematical series that progresses from three to
infinity.

Johns soon turned to two similar subjects: Numbers and Alpha-
bets; both have a coherent, abstract quality. They are part of the
ordinary world, and generally (unless we are typographers) we
ignore their form. We also rarely question the significance of a

28

[handwritten margin notes: "against Lichtensteins Picture plane principle"; "Picture Plane"]

single number or letter, that is, how it compares with, say, a box or even a flag. How do individual letters or numbers interact with others to create language and meaning? With an apparent disregard for these questions, Johns arranged his subjects in simple rows that filled the entire canvas; the idea may have come from a school book or an oculist's chart. The numbers themselves were frequently stenciled using ordinary packing-case stencils, which enabled him to repeat effortlessly the letter's form and to concentrate on painting it (in encaustic). He did not make words or inscriptions; the letters are workmanlike and straightforward. Johns admitted to Leo Steinberg that he liked the stencil letters best, and Steinberg, in disbelief, pressed him further:

Q: Do you use these letter types because you like them or because that's how the stencils come?
A: But that's what I like about them, that they come that way.[17]

These paintings again gave Johns the chance to use a subject that is given, common or impersonal. The letters also become anonymous and "not looked at." This vocabulary is similar to that of the Cubist still life, in which standard objects—bottles, guitars, violins, and sheet music—are the basic material for formal analysis.

In three large canvases of similar size made in 1958 and '59,

22

21. *Three Flags*, 1959
Pencil on paper, 14½ x 20 in.
The Victoria and Albert Museum, London

22. Jasper Johns in his New York studio, 1963
Photograph by Alexander Liberman

23. *Figure 5*, 1955
Encaustic and collage on canvas, 17½ x 14 in.
Private collection

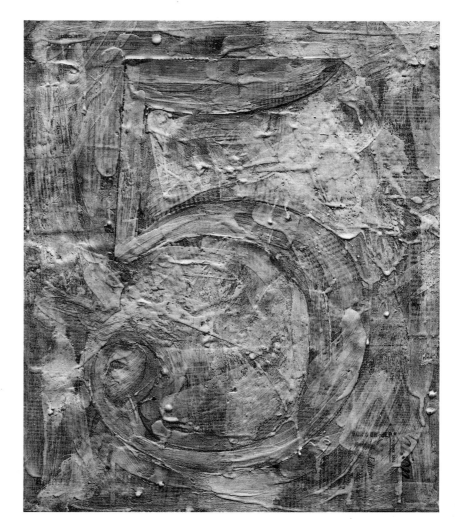

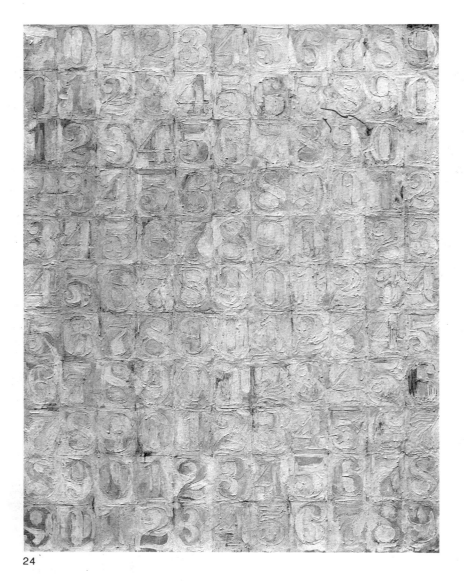

24

24. *Large White Numbers*, 1958
Encaustic on canvas, 67 x 49½ in.
Museum Ludwig, Cologne

25. *0 through 9*, 1959
Encaustic and collage on canvas,
20⅛ x 35 in.
Collection Ludwig, Aachen

26. *Gray Numbers*, 1958
Encaustic and collage on canvas,
67 x 49½ in.
Kimiko and John Powers

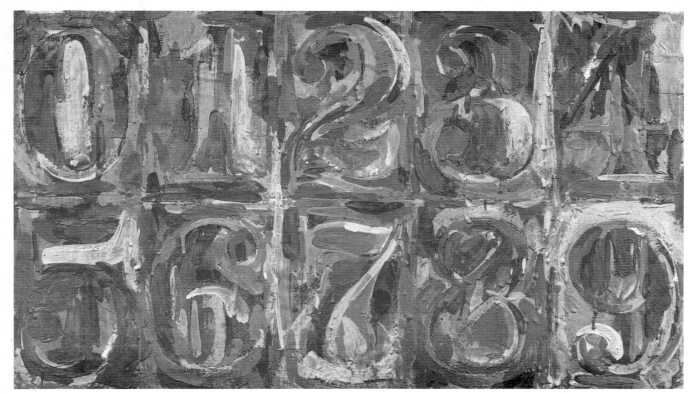

30

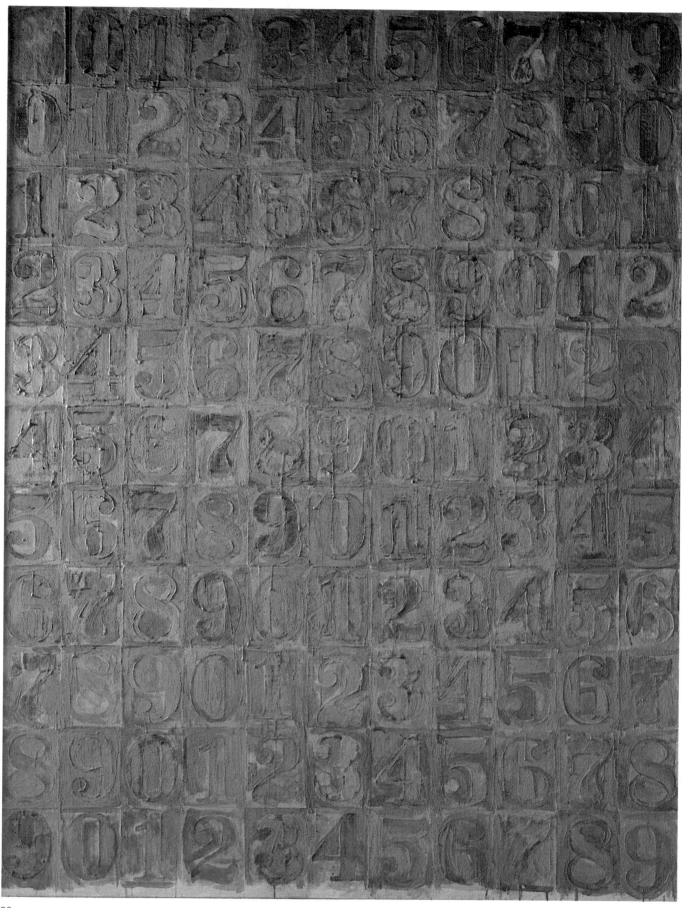

24, 26 Johns painted numerals: they are, respectively, white, gray, and colored (this last uses the primaries and black and white). They are painted all over within a consistent grid, except that the upper left-hand rectangle is left blank (collaged over like a mistake rectified in the gray work). There are eleven numbers in each row. Each vertical left-hand row begins with a different number, while the right-hand edge has the same numbers, except for the top row. In

27 these works, and in *Gray Alphabets* (1956), left and right and top and bottom edges are similar. We can imagine wrapping the work around a cylinder in either direction and the numbers would coincide. This is a device that Johns has returned to more recently; it is apparent, for example, in the crosshatched paintings of 1973–76 and after. His interest in the picture plane is therefore very different from that of the Cubists: where they were challenging its integrity by pushing elements onto it or through it, Johns insists on its integrity, its continuous membranous structure. Johns first kept the letters and numbers in rows on the same plane; later he experimented with superimposition and transparency. At this date he was working from 0 *to* 9, later from 0 *through* 9; the precision of the title is again important.

Robert Rauschenberg's combine paintings of 1959—collections of everyday objects with painted elements—exemplified clearly his

27. *Gray Alphabets*, 1956
Encaustic and newsprint on canvas,
66 x 49 in.
Private collection

28. *Alphabets*, 1957
Pencil and collage on paper, 14½ x 10½ in.
Mr. and Mrs. Robert Rosenblum, New York

Modernist.

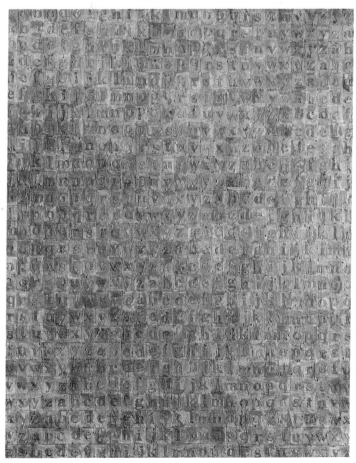

27 28

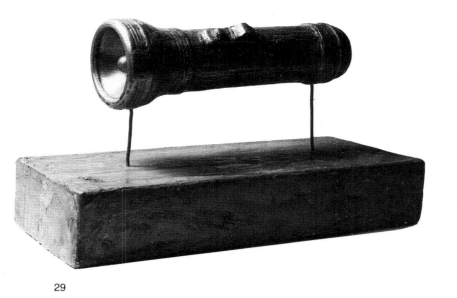

29

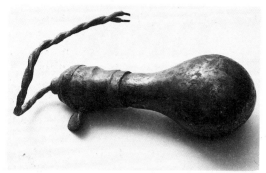

30

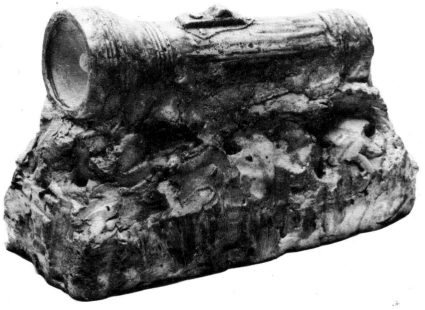

31

Duchamp

29. *Flashlight I*, 1958
Sculpmetal over flashlight and wood,
5¼ x 9⅛ x 3⅞ in.
Sonnabend Gallery, New York

30. *Light Bulb II*, 1958
Sculpmetal, 3⅛ x 8 x 5 in.
Collection of the artist
On loan to Philadelphia Museum of Art

31. *Flashlight III*, 1958
Plaster and glass, 5¼ x 8¼ x 3¾ in.
Private collection

desire to act "in the space between art and life." But whereas Rauschenberg was creating through massed heterogeneity (the most famous of the combines, *Monogram*, was a painting–sculpture that included a stuffed goat with a tire around it), Johns, in a more cerebral, considered fashion, was searching for a universal in the everyday. "I had this image of a flashlight in my head and I wanted to go and buy one as a model." Sylvester noted, "So the flashlight you wanted was an ideal flashlight, without particular excrescences, a kind of universal flashlight and in reality it was peculiarly elusive." "Yes it turns out that actually the choice is quite personal and is not really based on one's observations at all."[18] Johns took the flashlight and submitted it to various transformations, covering it first with sculpmetal (an amateur modeler's compound), and raising

29, 31

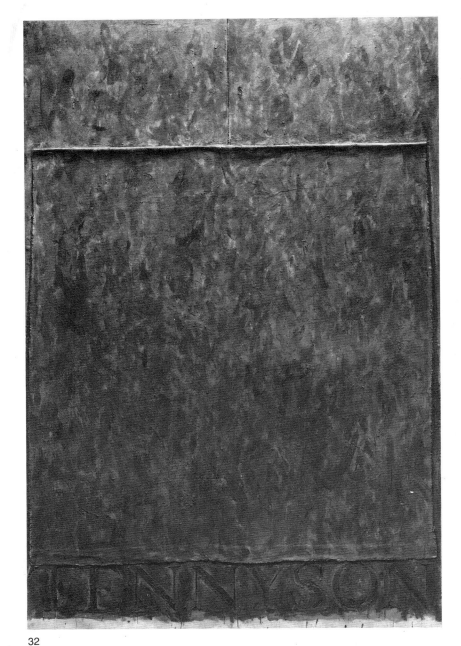

32

it like a museum specimen on spikes above a base, then making it in papier-mâché and glass, and finally in plaster and glass. (Some of these were also cast into bronze.)

32 In *The* (1957) and *Tennyson* (1958) the subject is the evocative power of the word and its resonance (cultural, literary, and linguistic). *Tennyson* uses the same formula as *Shade* in that the principal area of the image is covered by an additional piece of canvas. The underpainting in primary colors is similarly obscured by the gray encaustic. Clearly the work is as much about the problems of painting as it is about the English poet. However, there is correspondence, perhaps mostly in mood, between the poet and this enigmatic painting, a mannered sensitivity echoed by Johns's seemingly uncharacteristic use of Roman lettering. Johns went

35 farther with *No* (1961), where he suspended the metal letters N O from a wire in front of a gray picture plane; the word stands

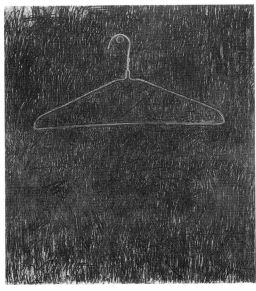

33

between the spectator and the picture surface and casts a shadow on that surface that has a ghostly presence within the gray paint.

The use of an object, the art object's usefulness was also questioned in the group of Johns's paintings that incorporate everyday objects. He took a coathanger, painted the ground with the outlined shadow, and added the object itself. That useful, universal object is rendered useless here; to use it you would have to dismantle the painting, where its usefulness is defined in terms of the painted rather than the real world. The complexity of this paradox reverberates through Johns's work, from paintings like *Coathanger* (1958) to examples such as *According to What* (1964).

34

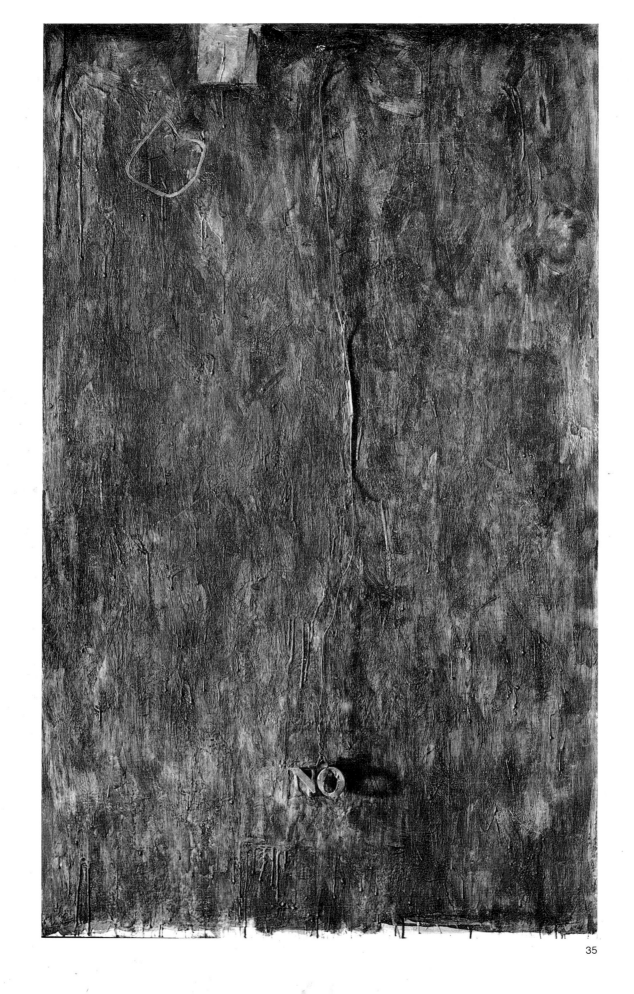

35. *No*, 1961
Encaustic, collage, and sculpmetal on canvas
with objects, 68 x 40 in.
Private collection

36. *Highway*, 1959
Encaustic and collage on canvas, 75 x 61 in.
Mrs. Leo Castelli

The paintings of 1958 are almost all gray, a color that both hides and defines those things placed upon it. Johns said of them:

I used gray encaustic to avoid the color situation. The encaustic paintings were done in gray because to me this suggested a kind of literal quality that was unmoved or immovable by coloration and thus avoided all the emotional and dramatic quality of color. Black and white is very leading. It tells you what to say or do. The gray encaustic paintings seemed to me to allow the literal qualities of the painting to predominate over any of the others.[19]

The work is reduced to this single color to establish the fact of its existence. He made the significance of this choice very clear when he had said to Walter Hopps, "I think if there was any thinking at all, or I have any now, it would be that if the painting is an object, then the object can be a painting."[20] Johns wanted to deal in facts, not in the effects that his objects would have; he realized soon afterward that even the things he chose, like the flashlight, were not securely standard objects. He had said that a painting was similar to a radiator. "Originally, I meant the radiator was a secure object one didn't have to bring any special psychological attitude to. Now [1969], I'm not so sure."[21] Johns moved first to using color more expressively and then to painting in oil.

Gray Rectangles (1957) and *Highway* (1959) are similar in format; they resemble, too, the large charcoal drawing *Night Driver* (1961). The 1957 work has three smaller canvases that are colored red, yellow, and blue set into its surface below the gray. The subject is a combination of the "hidden" characteristics of, say, *Book* and Johns's new interest in the adulterated object. Everyday things are not involved; instead the painter's objects—his colors at their most abstract—were pressed into service in the making of *Gray Rectangles*. The later works arose from Johns's observing the taillights of a car while driving back into New York one night; here the formal combination came after a fleeting observation. Johns made relatively small changes in format from *Gray Rectangles*. The handling, however, is radically different. *Highway* is made in a style that began with two works usually regarded as companions: *False Start* and *Jubilee*, both of 1959 (*False Start* was named after a sporting print in the Cedar Bar, which was frequented by artists). They were the works made after Johns's successful first exhibition; they are in oil paint, they are abstract (not objects), and they deal with color both as subject and object. Johns's stenciling of the names of the colors—their naming by label—is the most significant change: "The idea is that the names of the colors will be scattered about on the surface of the canvas and there will be blotches of color more or less on the same scale, and that one will have all the colors by name, more than by visual sensation."[22]

Marcel Duchamp's influence on Johns was important. Johns had gone with Rauschenberg to see the Arensberg collection in Philadelphia around 1958–59, and this exposure to Duchamp confirmed for him his own need to maintain a distance between himself and his audience. Johns met Duchamp for the first time in 1959, and perhaps it was this growing friendship and reexamination of Duchampian ideas and motives that informed *False Start*

34, 36

39, 37

36

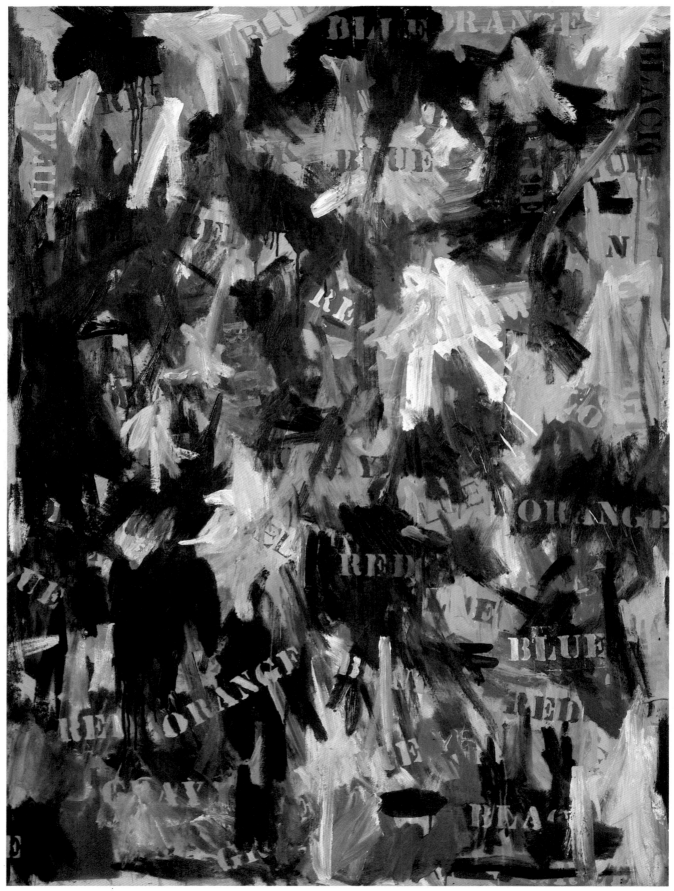

37. *Jubilee*, 1959
Oil and collage on canvas, 60 x 40 in.
Mr. and Mrs. S. I. Newhouse, Jr.

38. *By the Sea*, 1961
Encaustic and collage on canvas,
72 x 54½ in.
Private collection

39. *False Start*, 1959
Oil on canvas, 67¼ x 54 in.
Private collection

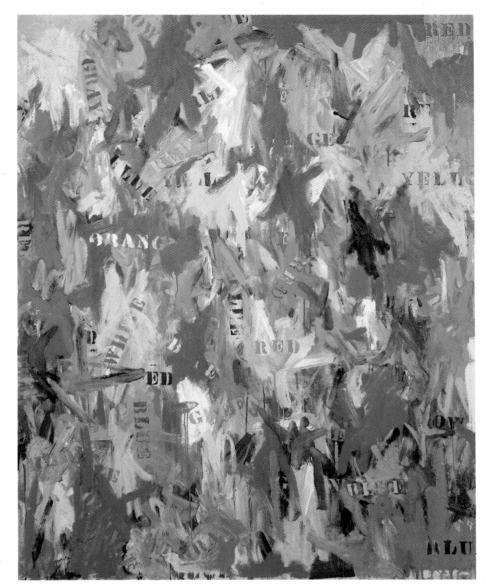

39

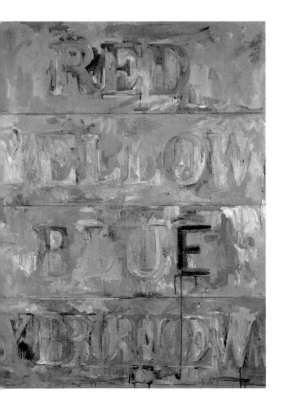

38

and *Jubilee*. Johns's own review of the typographic version of Duchamp's *Green Box*, published in 1960, yields clues to his admiration for the older artist: "Duchamp's wit and high common sense . . . the mind slapping at thoughtless values, his brilliantly inventive questioning of visual mental verbal focus and order (. . . the vision of an alphabet 'only suitable for the description of this picture') inform and brighten the whole of this valuable book."[23]

We can also find references in these paintings of Johns's to Abstract Expressionism: the handling of the paint has that familiar gestural quality, with dripped underpainting and an unfinished edge. But the inclusion of letters and named colors is more cerebral. Johns's standard alphabet and his use of names of colors define and mislead; the names of colors are spelled in different colors on the "wrong" patch of color. He is talking about color in terms relevant not only to this work but more generally to the essence, the nature of color and, by implication, to color-field painting.

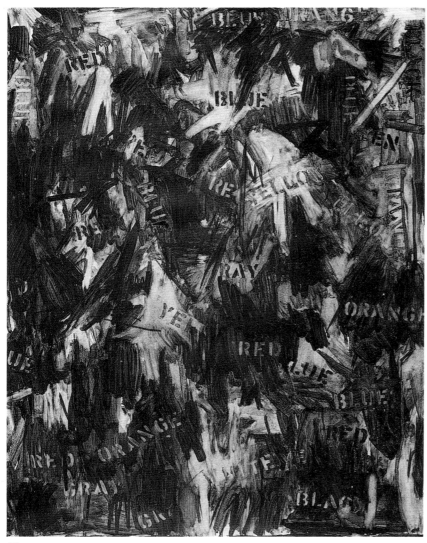

40

Johns placed his work precisely within the history of the art of the
1950s, for the viewer is confronted not with the cool indifference
of Duchamp's detailed manufacture (important, but no longer a
burning issue); rather, Johns's precision is paradoxically achieved
by the means he had eschewed until now: oil paint and gestural
brushwork. *Jubilee* seems to demand less from the viewer than
False Start. Its reticent palette acts as the equivalent of the standard,
colored object; black and white create their own emotional tenor.
It mirrors *False Start*, but it concentrates on the variants of its own
means, gray and black. Near the lower-right edge an image that
suggests the red and white stripes of the American flag is almost
entirely obscured. The subject of color is elaborated and confused
by the reintroduction of a motif concerned with the status of the
object. Was Johns quickly retreating from the apparent emotiveness
of *False Start* and looking for a restrained busyness?

Johns was included in Dorothy Miller's *Sixteen Americans* at
the Museum of Modern Art in 1959.[24] Miller selected Flags, Num-
bers, and Targets and showed these alongside *Tennyson*; the more

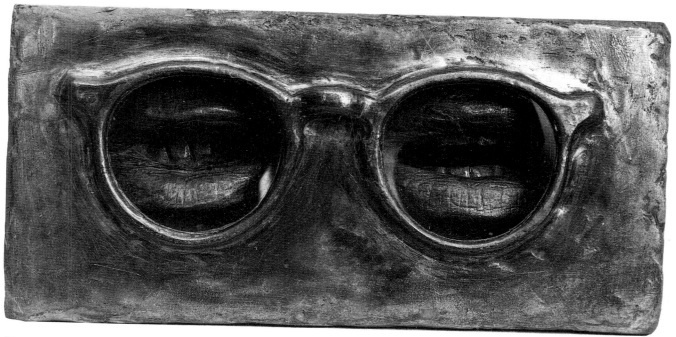

41

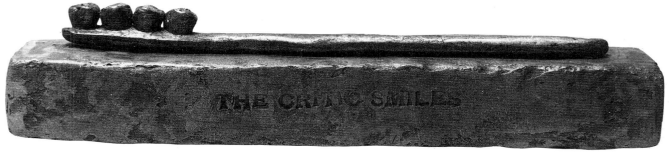

42

40. *Jubilee*, 1960
Pencil and graphite wash, 28 x 21 in.
The Museum of Modern Art, New York
The Joan and Lester Avnet Collection

41. *The Critic Sees*, 1961
Sculpmetal over plaster with glass,
3¼ x 6¼ x 2⅛ in.
Private collection

42. *The Critic Smiles*, 1959
Sculpmetal, 1⅝ x 7¾ x 1½ in.
Collection of the artist

developed canvases that extended the ideas found in these works were not shown until later. Johns's statement for the catalog established the arena in which critics were to discuss him for the next few years. He outlined his heroes (Cézanne, Duchamp, Leonardo) and adumbrated his technical interest in repetition, busyness, and the exploitation of "accidents." Indeed, the works that follow can be seen as responses in part to critical approval; a work such as *The* 42 *Critic Smiles*—the toothbrush with teeth as bristles on a slab of sculpmetal—does not disguise his ironic disregard for the critics. This is extended with greater precision and biting cynicism in *The* 41 *Critic Sees* in 1961. We should not write these off as *jeux d'esprit*; the painted bronzes were made at the same time, and, as I have shown, they expressed significant ideas. *The Critic Smiles* and *The Critic Sees* ask questions about the nature of the object, of sculpture, and about the function of criticism. They do so with a wit—Wittgenstein's "asides"—that may defuse their anger, but their intention is nonetheless serious.

At the same time Johns was constructing a group of works that

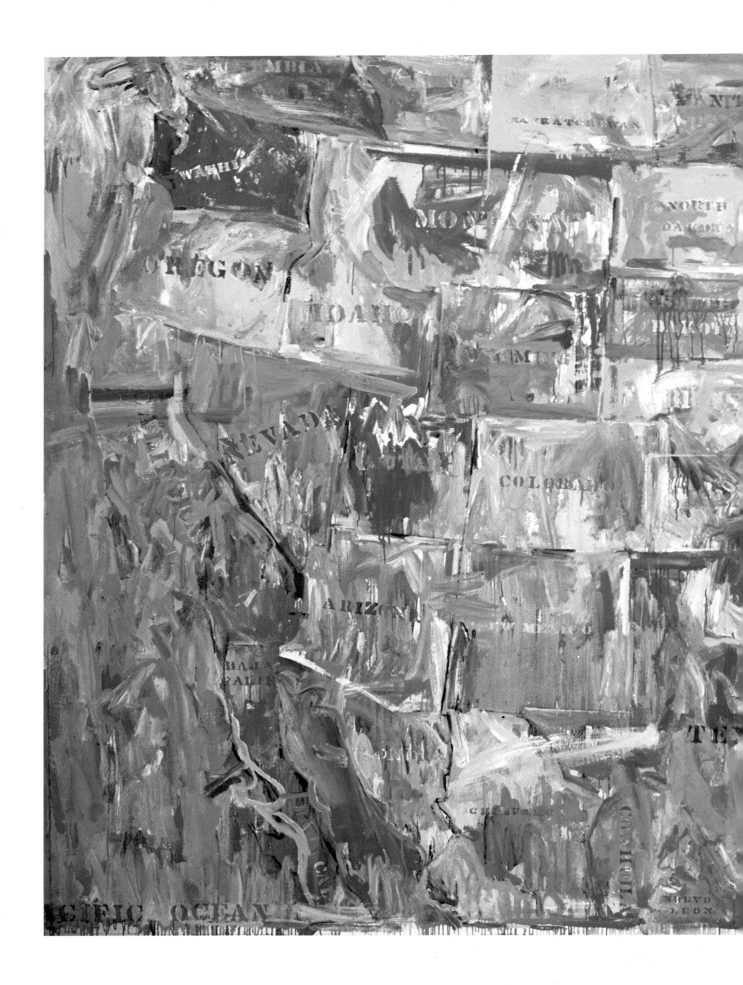

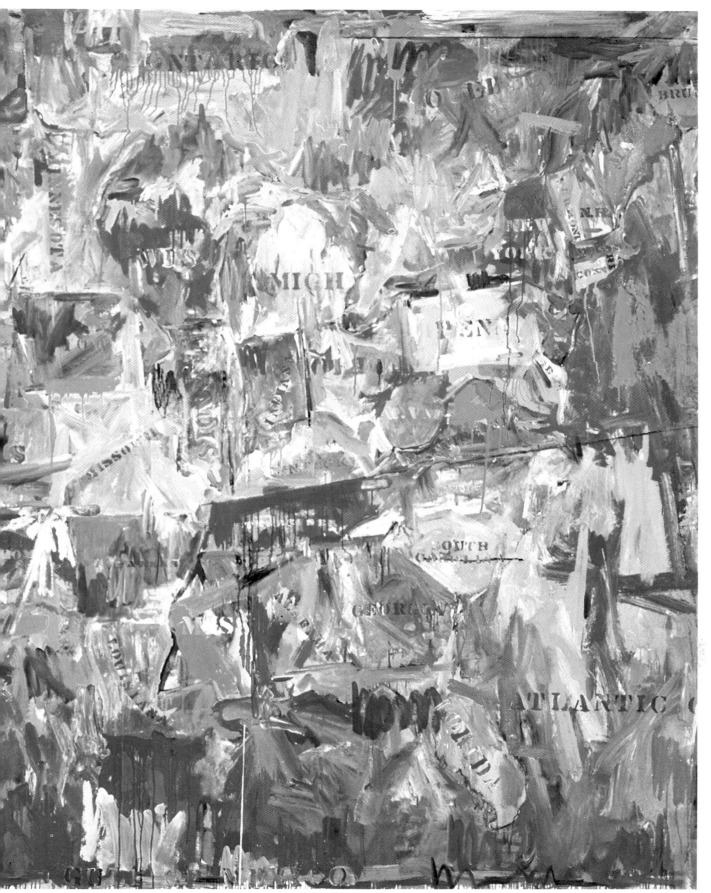

43 (caption overleaf)

44 45

dealt with earlier subjects in his newly painterly style. He made,
for example, five versions of the zero-through-nine motif that had
appeared previously in a drawing and lithograph; but now they
became mannered, sometimes extravagant, even baroque. The
whirls of paint and the mixed colors introduce a softer, pastel
palette, and the color apparently makes an emotional statement.
With these works the numbers are supports for this expression as
much as objects: there is a great technical beauty here. Johns also
worked on the American map, an obvious motif for him, but one
that he subverted through his method of making (see John Cage's
description, p. 114) and his disregard for geographic conventions.
He made a small version in 1960 and several large canvases over
the following three years. The series ends with *Map*, 1967–71,
based on Buckminster Fuller's Dymaxion Airocean Projection of
the World, which Johns made for the U.S. Pavilion at Montreal's
World's Fair of 1967. (Johns took it back after the fair to repaint
parts of it.) Alongside this relatively simple demonstration of the
world reduced to the terms of painting—flat, two-dimensional
surfaces with recognizable markings—Johns began a body of work
whose extension and elaboration he has continued since.
 Painting with Two Balls (1960), *Device Circle* (1959), *Painting
with Ruler and "Gray"* (1960), and *4 the News* (1962) deal again
with the picture plane, for their surfaces are either composed of
separate canvases bolted together to make the whole or divided by
a marking or measuring device. These works also demonstrate the

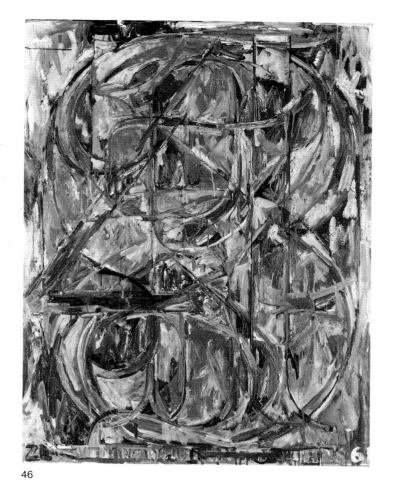

46

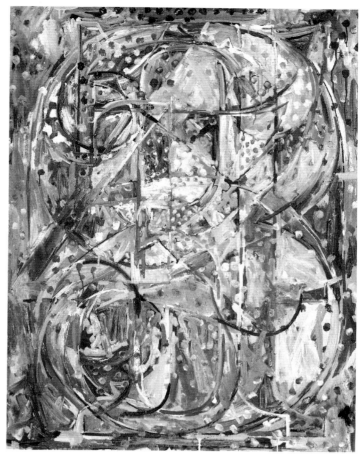

47

43. *Map*, 1961
Oil on canvas, 78 x 123⅛ in.
The Museum of Modern Art, New York
Gift of Mr. and Mrs. Robert Scull

44. *0 through 9*, 1960
Charcoal on paper, 29 x 23 in.
Collection of the artist

45. *0 through 9*, 1979
Ink on plastic, 11⅞ x 10¾ in.
Margo Leavin, Los Angeles

46. *0 through 9*, 1961
Oil on canvas, 54 x 45 in.
Tate Gallery, London

47. *0 through 9*, 1961
Oil and charcoal on canvas, 54⅛ x 41⅜ in.
Hirshhorn Museum and Sculpture Garden,
Smithsonian Institution, Washington, D.C.

results of acting in a specific way upon the surface. *Painting with Two Balls* is a variant of the broken Cubist picture plane, punctuated by two balls squeezed into the plane's surface—a still-life motif or an ironic comment on manly painterliness? With *4 the News*, the tawdry real world is inserted into the fabric of the painting: the work becomes a mail slot, the world passes through art. Both are constructed from specially made panels, show in their collaged surfaces many changes of mind, and, in a simple way, exemplify the color keys of *Jubilee* and *False Start*.

Johns adopted "devices" to alter the surface of the painting. Thus the ruler in *Painting with Ruler and "Gray"* is both a measuring device and a method of moving paint around the surface. It acts as a recording mechanism of the process of making, since the object and its action are integral to the work. The ruler is changed into another object, the painting stick, and thus fulfills Johns's desire to modify the use of an object in his work. These devices were to stand Johns in good stead over several years, although later they also became devices to recapture memory and mementoes from the layers below the surface of the painting. They also freed him from the act of painting, from expressing emotions through gesture in paint, since their dragging of the paint was mechanical and within particular bounds. This denial of involvement could be likened to Duchamp's use of rectified Readymades, where the object itself and the use to which it is put represent the artist's approach to art making.

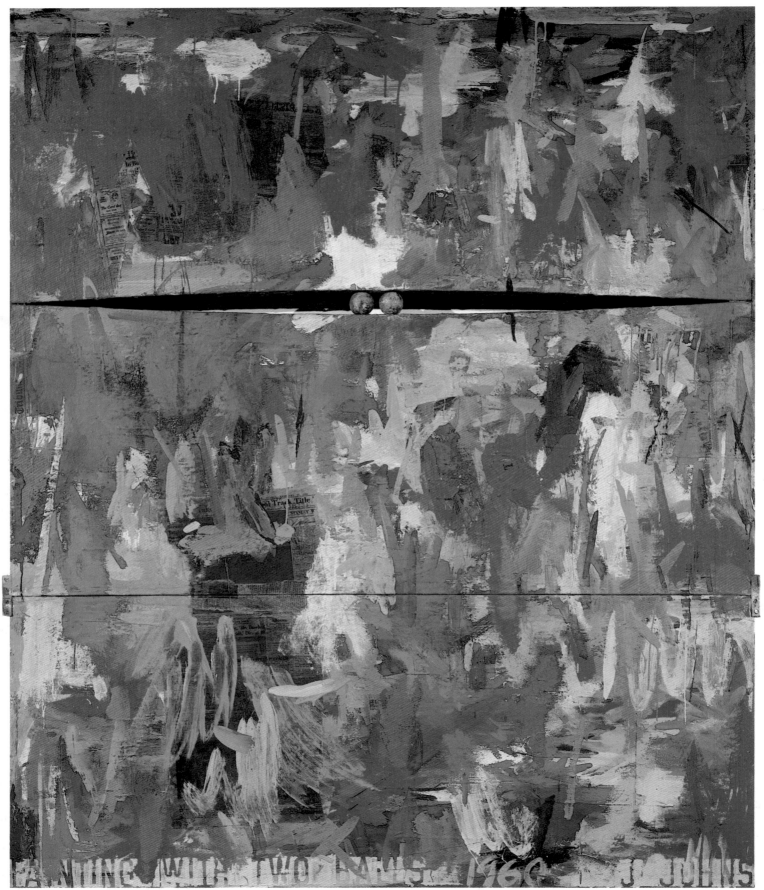

48. *Painting with Two Balls*, 1960
Encaustic on canvas with objects, 65 x 54 in.
Collection of the artist
On loan to Philadelphia Museum of Art

49. *Device Circle*, 1959
Encaustic and collage on canvas with objects,
40 x 40 in.
Mr. and Mrs. Burton Tremaine,
Meriden, Connecticut

The critics were divided about these works with devices: the modernist apologists Dore Ashton ("Technical excellence often outweighs his imagination") and Clement Greenberg seemed to have missed the point. Greenberg wrote: "But the fact that as much of his art can be explained as has been explained [here] without the exertion of any particular powers of insight would indicate a certain narrowness."[25] They had missed the point that Johns was not the opposition to the Abstract Expressionists, rather that he had found another solution that could incorporate and

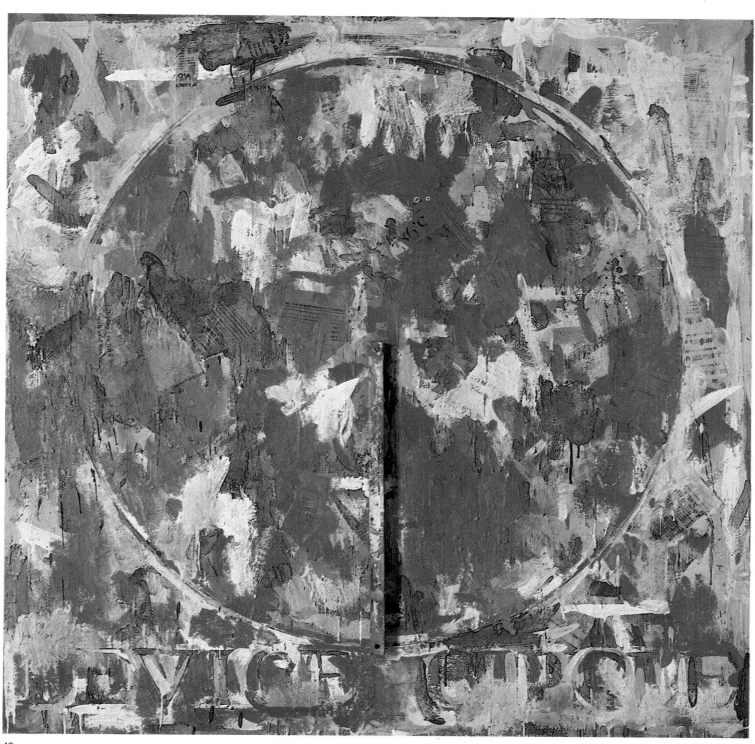

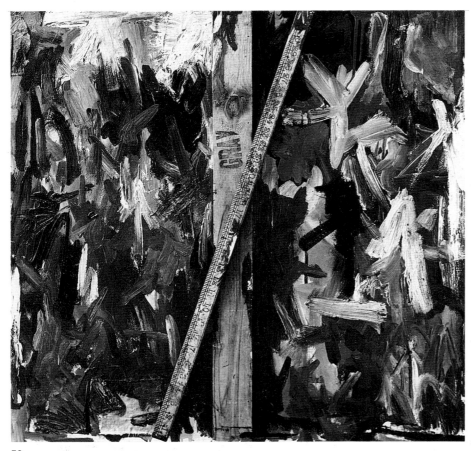

50

solve some of the questions posed by those artists. In his 1978 interview with Peter Fuller, Johns replied as follows to a suggestion that he was an artist "primarily concerned with ideas":

That's a critical thought that is often repeated. Now, this sounds an awful thing to say, but I still think it's based on people's experience of Abstract Expressionist painting, and the kind of subjectivity indicated in much of it, even in the very fine Abstract Expressionist painting. The artificial construction people make is that painting is not intellectual, and does not involve much thinking, but involves psychic or subconscious pressures which are released through the act of painting. But I think painting like mine shows obvious kinds of hesitation and reworking which people associate with thought. (laughs)[26]

Those critics would happily allow that Johns's work was filled with ideas, but preferred to restrain his area of thought to formal problems, those of modernist self-referential art. They also did not see that Johns's work was more personal than ever before. Leo Steinberg wrote in 1962 of these works: "the symbolism of his 1961 gray paintings is both more overt and more impenetrable. The painter past thirty dares to be frankly autobiographical because his sense of self is objectified and because he feels secure in the strength of his idiom."[27] Steinberg's referents are European; the philosophy that he alludes to is the European existential move-

Existentialism

50. *Painting with Ruler and "Gray,"* 1960
Oil and collage on canvas with objects,
32 x 32 in.
Private collection

51. *4 the News,* 1962
Encaustic and collage on canvas with objects,
65 x 50¼ in.
Kunstsammlung Nordrhein-Westfalen,
Düsseldorf

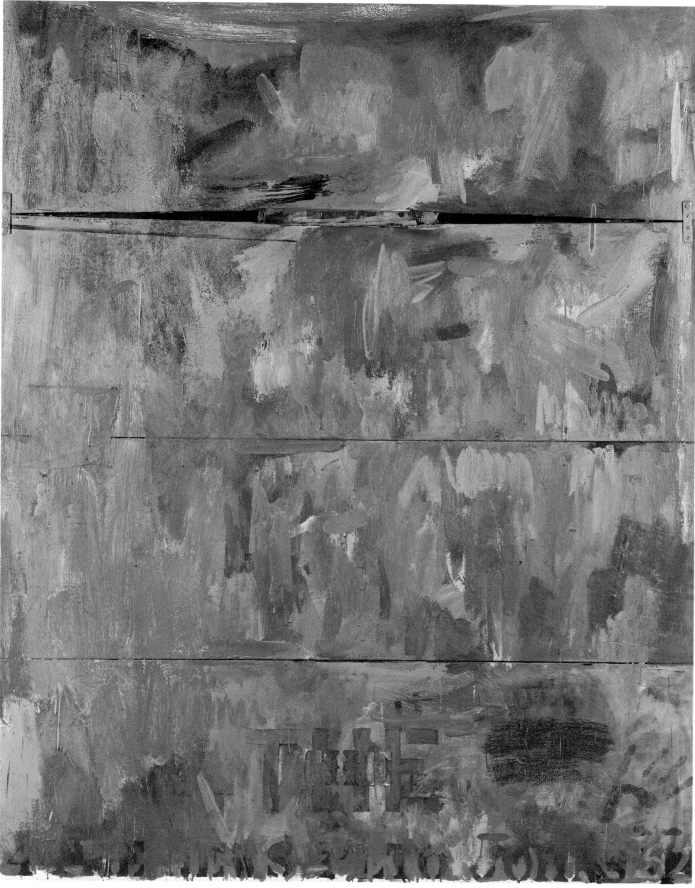

51

52

ment and its extensions into the linguistic investigations of Ludwig Wittgenstein. When Steinberg told Johns that his early works seemed to be "about human absence," the artist replied that this would mean their failure for him; for it would imply "that he had been there" whereas he wants his pictures to be "objects alone." Johns seems to have revoked this wish in the early 1960s, allowing the emotional drive to exhibit itself in the fashion of, say, Wittgenstein's *Philosophical Investigations*, where the investigation of personal and emotional motives is under the guidance of philosophical good manners.

Johns had systematically read Wittgenstein through the summer of 1961 and absorbed the particular investigations of language, the ordering of thoughts, and the questions about meaning in language that had preoccupied Wittgenstein. We cannot, of course, transfer ideas verbatim from one medium (writing) to another (painting), but we might imply a relation between the books Johns had been reading and the increased complexity of meanings in the works. He embarked on a series of works in which the allusions are sometimes obvious, but in which he used, in a characteristically conservative way, the vocabulary he had built up over several years.

55 *Land's End* (1963), for example, incorporates a divided canvas, colored letters, scraped areas of paint, and imprints of the artist's anatomy. These works do show "human absence" more clearly

53

54

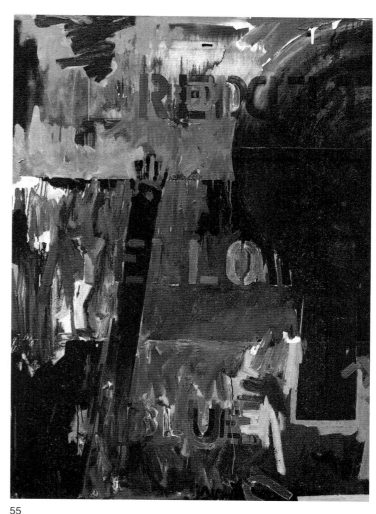

55

than the Flags and Numbers, if only because the impressions left by the figure are there on the surface. But there is more. This intervention by the artist in his own work, impressing himself upon it, is part of painting's own vocabulary. The implication of the figure (absent but traced out) in the *Diver* pieces (1963), for example, is that he has dived into the painting, broken its surface, shattered its flatness. We are given an aerial view of an action performed: we are shown the board, the position the hands take, and the sweep of the arms before takeoff. Each of these parts is, significantly, also an element in Johns's means. The arms trace out an area, scraping paint, like the devices in *Device*; they are disposed on either side of a bisected picture plane whose surface is indicated by expressive strokes. The area where this device is put to work is flanked by other motifs and references. Thus, on the left is a panel that doubles the arm movement with a circle "device." Expressive gray paint is juxtaposed with a full-length photographic gray scale, and on the right the "diver" breaks into an expressive area where the stenciled letters are enlarged and submerged in a luscious field of paint.

Simultaneously, Johns was also making groups of work named

51

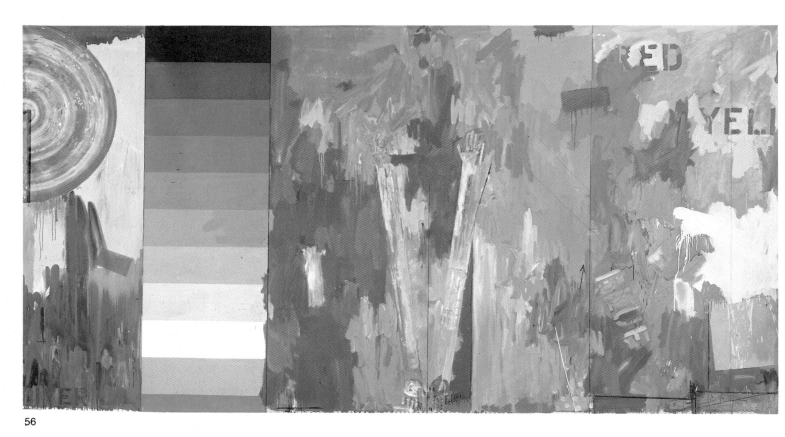

56

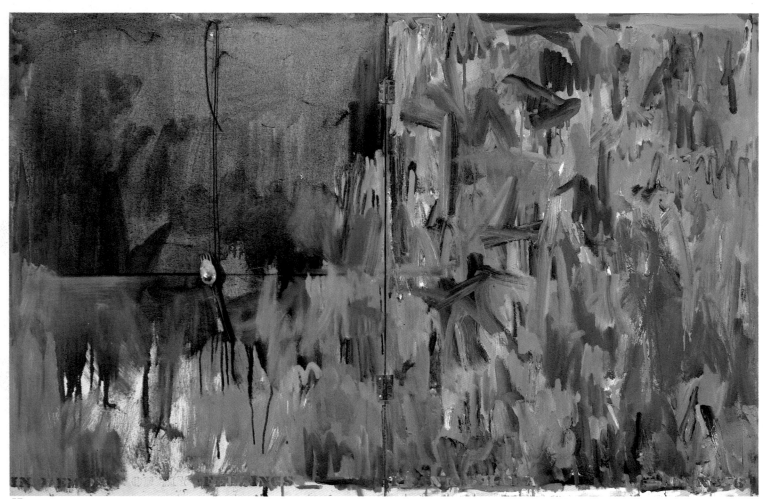

57

after places and works whose titles contain personal or literary references. Frank O'Hara—poet and curator at the Museum of Modern Art—was a friend of Johns, and Johns responded in a painting to O'Hara's poem, "In Memory of My Feelings." The [57] painting is made of two hinged canvases so that it can be folded upon itself (to hide the feelings?). It is loosely painted on the right in grays over exuberant underpainting; on the left it is divided horizontally and painted on the bottom half, while the upper is only darkly stained. At the top of the left panel hangs a fork and spoon (bound together, used) from a wire: these cast a shadow. The title of the painting is stenciled across the bottom. The work is abstract, and it relates to others (*Tango, No*), but the poignancy of the poem is clearly conveyed. Johns also made a cast of the poet's

56. *Diver*, 1962
Oil on canvas with objects, 90 x 170 in.
The Albert A. List Family Collection

57. *In Memory of My Feelings—Frank O'Hara*, 1961
Oil on canvas with objects, 40 x 60 in.
Stefan T. Edlis

58. *Periscope (Hart Crane)*, 1963
Oil on canvas, 67 x 48 in.
Collection of the artist
On loan to National Museum of American Art, Smithsonian Institution, Washington, D.C.

58

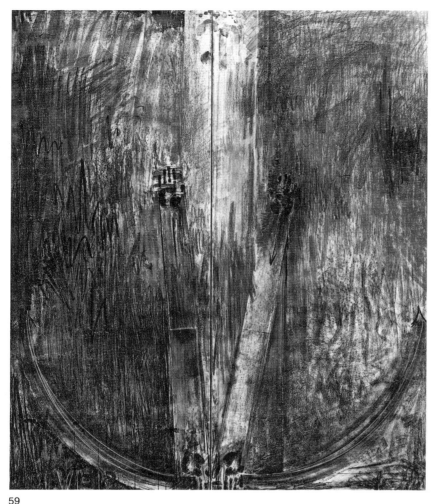

59

foot in 1961 and a drawing for a sculpture in which the footprint could be impressed in sand in the drawers of a specially constructed box. He had also begun to work on a collaborative project with O'Hara, which was cut short by the poet's tragic death in an automobile accident in 1966. (One lithograph, *Skin with O'Hara Poem*, was completed in 1963; the sculpture was finally made in 1970.)

Johns has found a way of expressing the emotional ideas of literature through the handling of paint. The works of these years are desperate, and this despair is often based on specific responses to literature or to a place. *Periscope (Hart Crane)* (1963), for example, is a reference to Hart Crane's quatrain:

> A periscope to glimpse what joys or pain
> Our eyes can share or answer—then deflects
> Us, shunting to a labyrinth submersed
> Where each sees only his dim past reversed. . . .

Johns had made four versions of *Study for Skin* (1962) by covering himself with oil and pressing against a sheet of drafting paper, which was then dusted and rubbed lightly with powdered graphite. The image of the artist is imprisoned within the paper. It is an

60

59. *Diver*, 1963
Charcoal and pastel on paper mounted on
canvas, 86½ x 71 in.
Mr. and Mrs. Victor W. Ganz

60. *Study for Skin I–IV*, 1962
Charcoal on paper, 22 x 34 in. each
Collection of the artist

image found, not drawn. Johns repeated the procedure again in
1973, this time only over his buttocks and genitals. The increased 61, 62
"weight" (the darker gray of the image), and the fact that the artist
has obviously aged, add authority and poignancy.

Johns's fame had brought him financial success and an increas-
ing pressure to make himself and his art available to a wider
public. He responded by moving away from the city in what was
to become a characteristic tactic of strategic withdrawal. In 1961
he bought a house at Edisto Beach, South Carolina, and began to
paint there. John Cage recalls the place:

On the porch at Edisto. . . . Henry's records filling the air with Rock 'n'
Roll. . . . I said I couldn't understand what the singer was saying. . . .
Johns (laughing): That's because you don't listen. . . . The thermostats
are fixed to the radiators but lead ineffectually to two bare wires. . . . The
Jaguar repaired and ready to run sits in a garage unused. . . . It has been
there since October. . . . An electrician came to fix the thermostats but
went away before his work was finished and never returned. . . . The
application for the registration of the car has not been found. . . . It is
somewhere among the papers which are unfiled and in different places. . . .
For odd trips a car is rented. . . . If it gets too hot, a window is opened. . . .
The freezer is full of books. . . .[28]

61

56

62

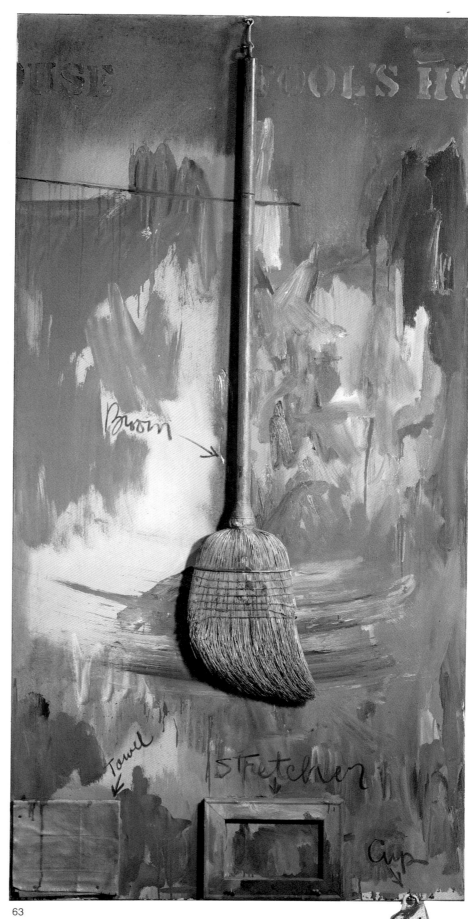

61. *Skin I*, 1973
Charcoal on paper, 25½ x 40¼ in.
Collection of the artist

62. *Skin II*, 1973
Charcoal on paper, 25½ x 40¼ in.
Collection of the artist

63. *Fool's House*, 1962
Oil on canvas with objects, 72 x 36 in.
Jean Christophe Castelli

63

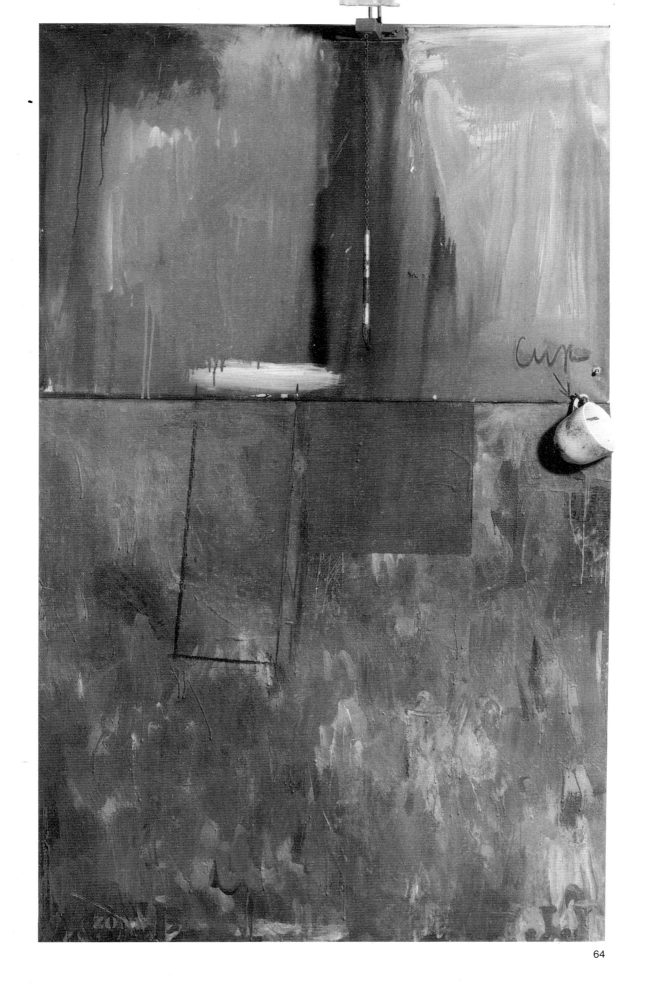

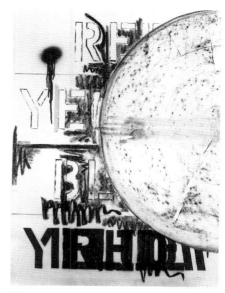

65

None of the pictures of 1962–64 stands apart in terms of its ideas or motifs. All are "impure," but *Fool's House, Zone, Slow Field,* and *Field Painting* continue the investigation of the problems of incorporating real objects within the painted object. *Fool's House* 63 carries the insignia of the smaller reversed canvas and applied objects that are named on the work. The broom also modifies the surface: it is a brush/device. The surface has a drawn central division, and an inscription runs from the center to the right, and then continues on the left side; it wraps around and suggests a cylindrical canvas. In *Zone* the brush hangs freely, and the surface 64 is divided both horizontally (there are two canvases—one in oil, one in encaustic) and by the imposition of areas drawn or painted around or painted darkly. The inscriptions are made several times in different sizes at the base, and an illuminated blue neon letter A and a wooden T project from the top edge. These works are relatively reticent and somber, each an extension of the language found in paintings such as *4 the News*. They, with others already discussed and *Out the Window* (1962), are the prelude to the "field" paintings. *Slow Field* incorporates many of these elements 66 again: the smaller canvas is hinged and conceals a real brush. This information is drawn on the larger canvas, as if an impression had been made, and "canvas," "stretcher," and "brush" are also named. The central division, like the runway in the *Diver* works, is a wide band, but here the letters of the words for the colors are mirrored along the central axis and painted in gestural strokes. To the left is the highly wrought color field and to the right a stained area and a polka-dot rectangle similar to a *o through 9* of the previous year. This is followed by a further extension in *Field* 67 *Painting* of 1963–64, in which the separate canvases are divided and from them project three-dimensional versions of the letters with everyday objects and a neon R. These objects include elements of Johns's personal iconography, such as an ale can, Savarin tin, knife, roll of solder, paintbrush, and printmaking squeegee. The canvases themselves are quite distinct, the left being the most expressive so far—on this occasion it contains the black, gray, and the colored palettes and gives the impression of having been painted quickly. The right is a cool, worked blue-gray in which the letters have been inscribed and superimposed. It has traces of its working in the bottom edge, and in the yellow sprayed drip and circle marking the base of a can. It has also the white impression of a foot on its upper right edge, and the outline of a Duchamp sculpture *Female Figleaf*, which can also be seen in *No* and several other works.

The title *Field Painting* refers to the painter's field (as in *Flag on an Orange Field*) but here the field is reconstituted, subverting the picture plane through its projections. The attached objects are real versions of Johns's sculptural output; the painting is encyclopedic in its conjunction of formal flatness of painting and his sculptural forms. Moreover, it sums up what he had already achieved, starting with the expressionist field on the left and looking forward to the cooler fields of *Studio* (1964) and *Harlem Light* (1967) on the 79, 84 right.

Johns made two versions of his *Souvenir* painting in Japan in 68, 69

64. *Zone*, 1962
Oil, encaustic, and collage on canvas with objects, 60 x 36 in.
Kunsthaus Zurich

65. *Untitled*, 1963
Charcoal, collage, and paint on paper, 42½ x 30 in.
Mr. and Mrs. Victor W. Ganz

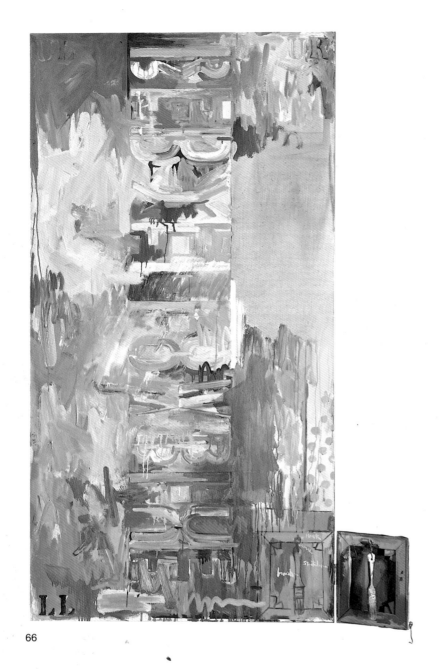

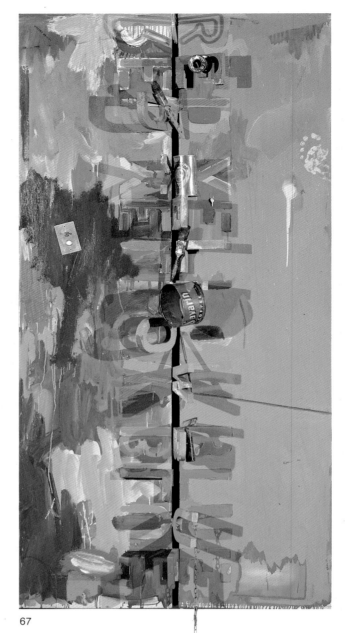

66

67

1964. The elements are banal enough: a flashlight (used before), a rear-view mirror angled (it would appear) to reflect the beam from the flashlight onto a Japanese souvenir dinner plate that photographically depicts the artist encircled by the named primary colors. According to his *Sketchbook Notes*, Johns had seen, in a theater, reflections from a woman's handbag mirror playing on the ceiling and wished to incorporate the idea. The arrangement does not work in physical terms, but its intention is clear: to encourage the spectator to participate in the viewing and to highlight the artist and remember ("souvenir") him. The second version contains the now familiar motif of the turned canvas, which hides most of the base painting's surface from us. Johns produced drawings of both canvases soon after the paintings were made and returned to both subjects in drawings and prints made in 1969 and 1970. Each of the drawings is distinct; each explores variants of medium, color,

66. *Slow Field*, 1962
Oil on canvas with objects, 72 x 36 in.
Moderna Museet, Stockholm

67. *Field Painting*, 1963–64
Oil on canvas with objects, 72 x 36¾ in.
Private collection

68. *Souvenir 2*, 1964
Oil and collage on canvas with objects,
28¾ x 21 in.
Mr. and Mrs. Victor W. Ganz

background, and, in one case, support. Finally, Johns made lithographs from both subjects: *Souvenir 2* in 1970 and two versions of *Souvenir 1* in 1971 and 1972.

Johns's drawings are an essential element in his oeuvre and deserve a fuller treatment than they can be given here. They differ from the prints in that they concentrate less on variations in medium and more on an involvement with the transfer of the idea. This is not to deny Johns's virtuosity, his extreme delicacy and "touch" with graphite or whatever, since that is of crucial importance, but to make a stronger link between the facture—the made surface—of the paintings and those of the drawings. Their techniques vary

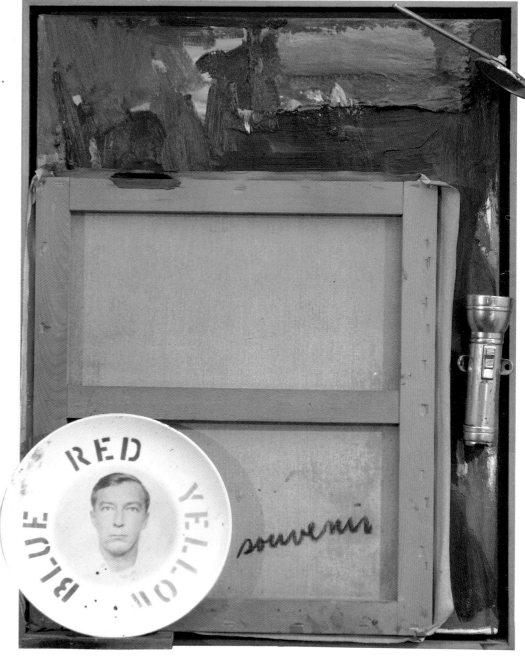

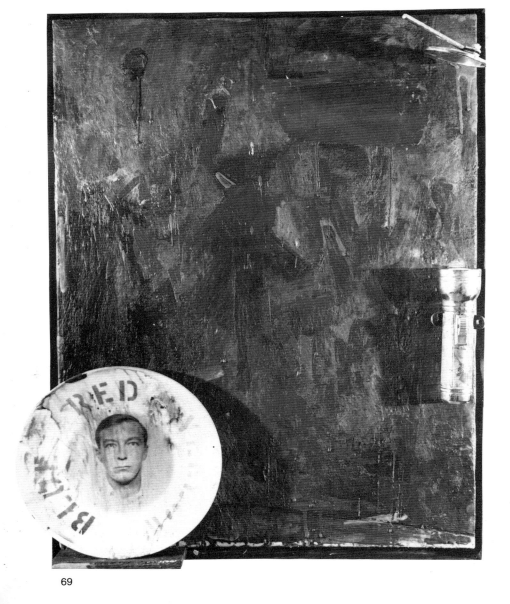

69

from subject to subject, and even within subjects. Compare, for
16 example, the Flag drawings of the mid-1950s—where the surface
is ruled and filled with exquisite overlays of hatched graphite—
with a drawing like *Two Flags* of 1960—where the graphite is
used like watercolor or diluted paint and glistens on the surface of
the paper. Johns seemingly frees himself within the constraints of
this apparently limited medium. He has often painted in ink on a
plastic drafting film often used by architects, which is dimension-
ally stable and similar to tracing paper with a mat translucent
surface; its nonabsorbency and resistance to cockling have left
puddles and washes of ink of the most intense pigmentation on the
surface. His sensitivity to this sort of effect (comparable in inten-
sity to Emile Nolde's secret wartime paintings in watercolor) con-
firms Johns's technical mastery. Furthermore, the subjects them-
selves—*Disappearance*, *Souvenir*, *Cicada*, for example—are en-
hanced by the remains of the emotional charge that accrues from
this surface.

Johns began printmaking in 1960 when Tatyana Grosman, foun-

69. *Souvenir*, 1964
Encaustic on canvas with objects,
28¾ x 21 in.
Private collection

70. *High School Days*, 1964
Sculpmetal over plaster with mirror,
4³⁄₁₆ x 12 x 4½ in.
Collection of the artist
On loan to Philadelphia Museum of Art

71. *Figures in Black and White*, 1969
Lithographs—10, edition of 40, 38 x 31 in. each
Gemini G.E.L., Los Angeles

70

der of Universal Limited Art Editions, delivered a lithographic stone to him. The medium had been largely ignored by the previous generation in America, and Grosman wished to reestablish printmaking as an important medium. Johns's first print was a Target, which was taken from a conté drawing, *Target* of 1958. 15 (This drawing relates, of course, to previous paintings.) Johns began relatively humbly, reworking drawings or paintings and discovering the potential of the medium. In the first year he had conceived the printing of the ten numerals 0–9, from a single stone. Johns's choice of this subject dictated a fixed order of printing, and since lithographic stones show the process of working, something always remains from each stage. These lithographs were finally executed and printed in 1963.

Johns developed his expertise in printmaking with U.L.A.E. at West Islip, New York, and later in Los Angeles at Gemini G.E.L.

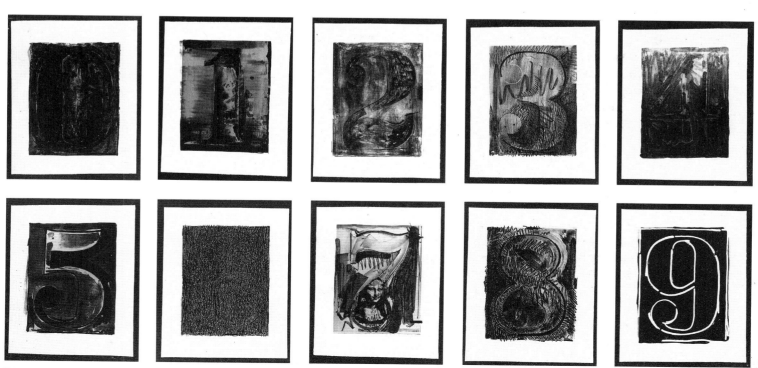

Over the next twenty years he would work with other publishers and printers, always seeking the greatest expertise from his printers and making the most stringent demands on the technique at his disposal. Other things interested Johns about printmaking. He deflected the criticism that he has only a limited vocabulary and answered a question from Christian Geelhaar about the reuses of images from his painting in his printmaking thus: "I like to repeat an image in another medium. . . . In a sense, one does the same thing two ways and can observe differences and sameness—the stress the image takes in different media. . . . I can understand that someone else might find that boring and repetitious, but that's not the way I see it. I enjoy working with such an idea."[29]

Johns is reported elsewhere as enjoying the delays inherent in printmaking, delays occasioned by the process itself, waiting for inks to dry or plates to be made, and, I suspect, a sort of Duchampian "delay." Duchamp referred to the *Large Glass* as a "delay in glass," something that detained the spectator for a few moments; Johns's prints, as they become more complex, have this quality too. They restrain the viewer in his approach to the subjects by the virtuosity of their means.

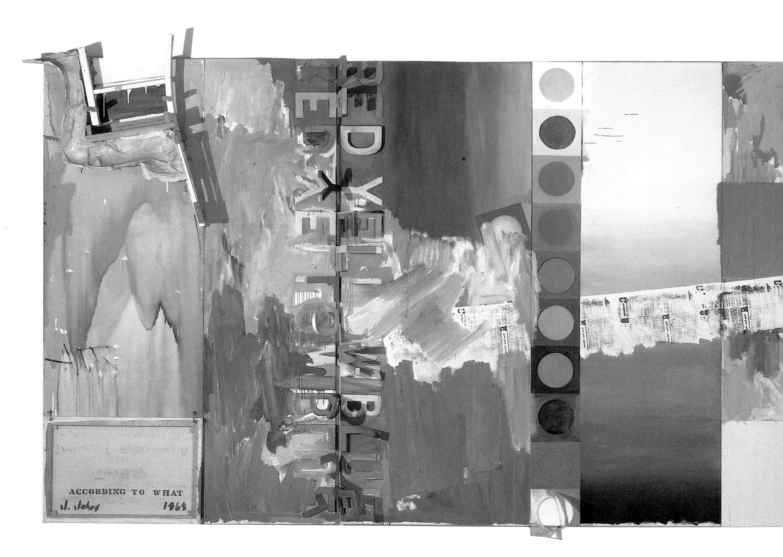

72. *According to What*, 1964
Oil on canvas with objects, 88 x 192 in.
Mr. and Mrs. S. I. Newhouse, Jr.

73. *Watchman*, 1964
Oil on canvas with objects, 85 x 60¼ in.
Hiroshi Teshigahara, Tokyo

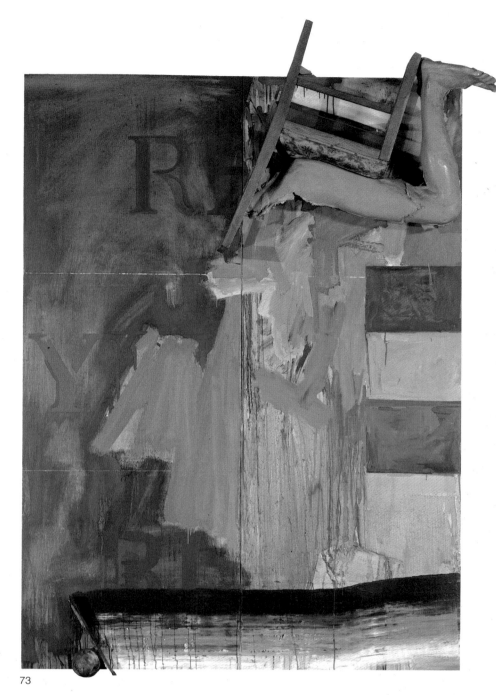

73

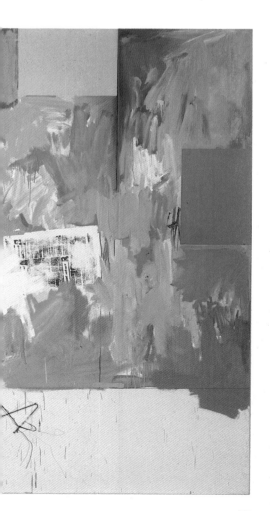

72

Johns also used printmaking over the next four years to investi-
gate particular elements from his earlier paintings and sculptures.
Thus part of *Pinion* is taken from the objects clamped together in
Eddingsville. He made lithographs of *Ale Cans* and *Voice*, *Watch-
man* and *Passage*. In 1966–67 he used etching for the first time. *1st
Etchings* delineate most of his sculptural oeuvre. From this date
Johns's printmaking and his painting have a symbiotic relationship;
elements from prints are used in paintings, elements from paintings
are further reworked in the prints, and reappear again in paintings.
In 1964 *Watchman* preceded *According to What*, and Johns's 73, 72

Sketchbook Notes from this period are the clearest guide yet to his working method and his allusive analytical mind:

Make neg. of part of figure and chair. Fill with these layers—encaustic (flesh?), linen, celastic. One thing made of another. One thing used as another. An arrogant object. . . . Put a lot of paint and a wooden ball or other object on a board. Push to the other end of the board. . . . Break orange area with 2 overlays of different colors. Orange will be "underneath" or behind. Watch the imitation of the shape of the body.[30]

This sort of note is relatively simple and applicable to the work. Other parts of the *Notes* allude to other paintings and to procedures that Johns was to adopt up to seven years later. He records for himself methods of working, particulars of objects, and suggests but does not define meanings. Another section has caused great speculation about the meaning of *Watchman's* title and its political implications:

75

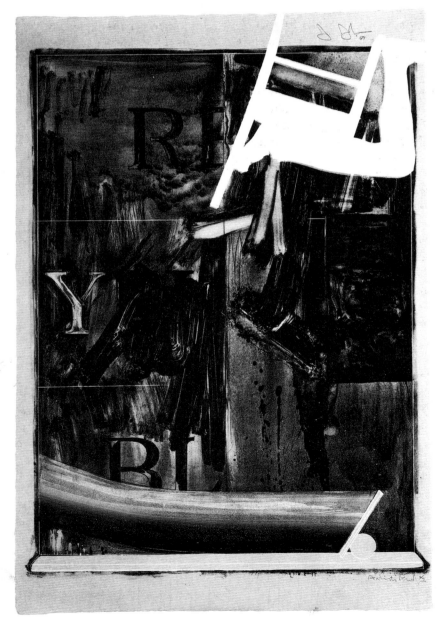

74

The watchman falls "into" the "trap" of looking. The "spy" is a different person. "Looking" is and is not "eating" and "being eaten." (Cézanne? —each object reflecting the other.) That is, there is continuity of some sort among the watchman, the space, the objects. The spy must be ready to "move," must be aware of his entrances and exits. The watchman leaves his job & takes away no information. The spy must remember and must remember himself and his remembering. The spy designs himself to be overlooked. The watchman "serves" as a warning. Will the spy and the watchman ever meet? In a painting named SPY, will he be present? The spy stations himself to observe the watchman. If the spy is a foreign object, why is the eye not irritated? Is he invisible? When the spy irritates, we try to remove him. "Not spying, just looking"—Watchman.[31]

It is difficult to imagine, as has been suggested, that this convoluted argument concerns America's political role in the cold war era. Freud's definition of the mechanisms of repression in his *Introductory Lectures on Psychoanalysis* is perhaps more illuminating, particularly on the role of the watchman.[32] Johns cannot recall the date at which he read this work.

The full summary of Johns's work to 1964 is contained in the large painting *According to What*, where he rehearses all the elements of the previous years. The work is divided into six canvases that display (left to right) part of the back of a cast leg and a chair, a reversed canvas (on the face of which is a stenciled silhouette of Duchamp), two- and three-dimensional letters, a row of colored circles with the metal template that was used to make them, real objects with painted and cast shadows, and a band of repeated silkscreened newspaper pages over white paint. It is a grand rhetorical statement, a machine in the fashion of nineteenth-century paintings such as Gustave Courbet's *Studio*. The intention is similar: to present, as Courbet's subtitle puts it, "a real allegory summing up seven years of my artistic life." We could compare the painter, easel, and model at the center of Courbet's work to the two joined canvases with projecting letters in Johns's. Both summarize the central thrust of the artist's work and are a report on "the state of the art" in 1855 and 1964. There are other links that could be made: to critics and to artists (Courbet's fellow workers and Duchamp), but where Courbet established a political allegory, Johns appears to be concerned with ways of making art.

According to What is modern in this respect, for it represents the mechanics of art making, not the world outside. The reference to Duchamp is twofold. First, Duchamp's profile is concealed beneath the hinged canvas, and, as with the casts in *Target with Plaster Casts*, it assumes an active spectator to discover it. Second, the overwhelming reference is to Duchamp's painting *Tu'm* (1918). This, Duchamp's last conventional easel painting, is a summary of work, a compilation of allusions to earlier works, in which cast and painted shadows, real objects and representations cohabit and penetrate the same surface. Johns's title sounds Duchampian and concerned with language, as if it begins (or ends) an argument of logical complexity.

74. *Watchman*, 1967
Lithograph—edition of 40, 36 x 24 in.
Universal Limited Art Editions, West Islip,
New York

75. Marcel Duchamp
Tu'm, 1918
Oil on canvas with objects, 27½ x 122¾ in.
Yale University Art Gallery, New Haven
Bequest of Katherine S. Dreier

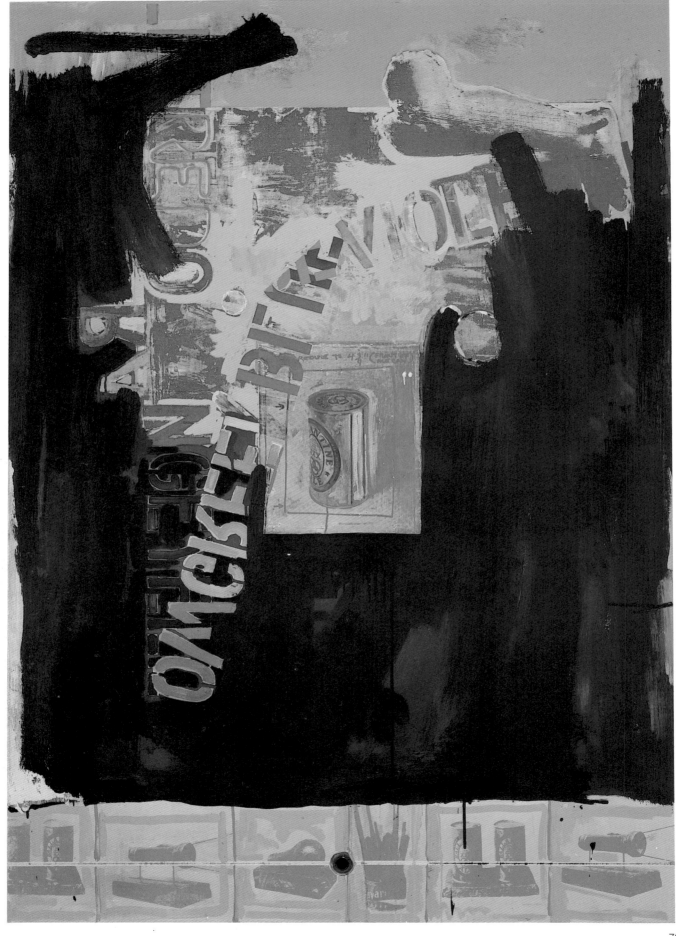

2 Shunning Statements, 1965–1972

In 1970 Johns was interviewed by Emile de Antonio for his film *Painters Painting*.[33] This is a group portrait created with interviews of the artists, dealers, and collectors then dominating the New York art market. In each case the film-making technique was intended to match the artist's own aesthetic: Andy Warhol, for example, was filmed looking into a mirror so that the whole film crew is reflected with him in each shot. Johns was interviewed in a straightforward way at his studio and home on the Lower East Side of New York, seated at his dining table with the radio playing in the background. Works, finished or partly finished, are on the wall behind him, and we glimpse another room where his earlier paintings hang above a Richard Serra lead piece. The studio is a large, converted banking hall, its main room some forty feet square and twenty feet high, with the furnishings cleared to the corners and a false wall built to paint on. It was a measure of Johns's success that he could acquire such a building and of his ambitions that he wanted to produce large canvases in it. Indeed, Leo Castelli talks in the film of the great increases in the prices of works by artists such as Johns, Warhol, and Rauschenberg.

Johns was engagingly courteous with his interviewer, answering the by now familiar questions about his work and disengaging himself from further revelation by prefacing his replies with jokes about the questions. When de Antonio asked him about his relationship to Dada, Johns replied: "What about dada? What kind of question is that?" but went on to reveal that when he first made the works dubbed "neo-Dada" by the critics, he had not heard of the term. Johns is essentially a self-taught artist and his progression from idea to idea was an educative process; like other autodidacts it enabled him to keep a personal and particular grasp of the problems that interested him. When Peter Fuller asked him in 1978 whether his interest in specifically American subjects was an extension of Abstract Expressionist themes with new subject matter, he replied: "My training as an artist is very modest, and my exposure to painting at that time—well, even now, but certainly then—was really very slight." His experience and reading had led him by 1964 via Duchamp and Wittgenstein to a more fully articulated expression of his position.

76. *Decoy*, 1971
Oil on canvas with object, 72 x 50 in.
Mr. and Mrs. Victor W. Ganz

77

David Sylvester talked to Johns in 1965 about the nature of reality and illusion and the possibility of emotional statement in an individual painting. At the end of the interview (as published), Sylvester said: "In other words it seems to me your constant preoccupation is the interplay between affirmation and denial, expectation and fulfillment, the degree in which things happen as one would expect and the degree in which things would happen as one would not expect." To which Johns replied:

Well, intention involves such a small fragment of our consciousness and of our mind and of our life. I think painting should include more experience than simply intended statement. I personally would like to keep the painting in a state of "shunning statement," so that one is left with the fact that one can experience individually as one pleases: that is, not to focus the attention in one way but to leave the situation as a kind of actual thing, so that experience of it is variable.[34]

psychoanalytical

Johns had already incorporated in his work the real world with casts and impressions of objects or by using the objects themselves, as themselves. In *Studio*, *Studio 2*, and *Harlem Light* he took this farther by impressing on the canvas parts of the rooms in which they were made. In *Studio*, Johns worked on the outside, impressing the screen door and a palmetto leaf. He also suspended a group of paint cans and a brush. (In *Eddingsville* a group of objects—

79, 80, 84

78

77. *Untitled*, 1964–65
Oil on canvas with objects, 72 x 168 in.
Stedelijk Museum, Amsterdam

78. *Eddingsville*, 1965
Oil on canvas with objects, 68 x 122½ in.
Museum Ludwig, Cologne

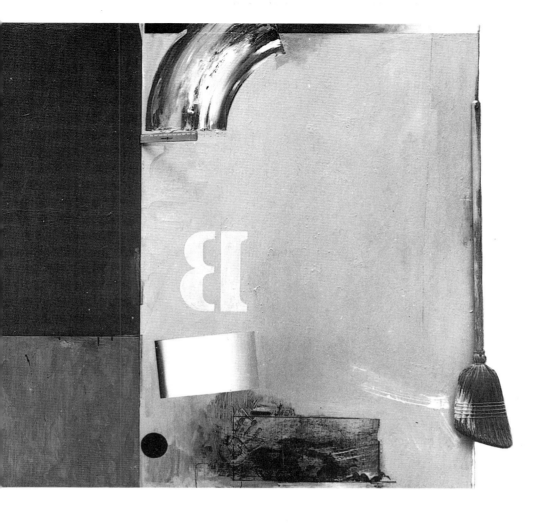

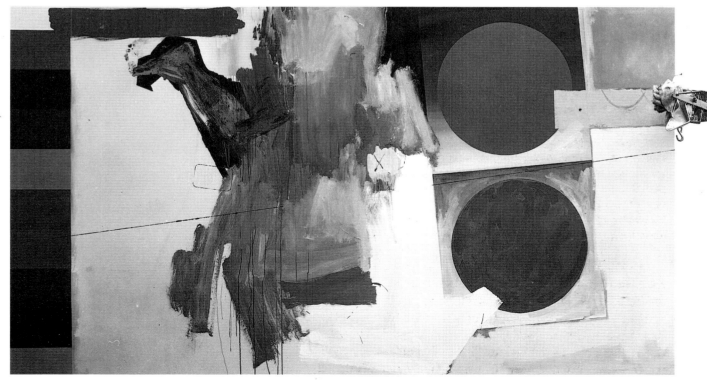

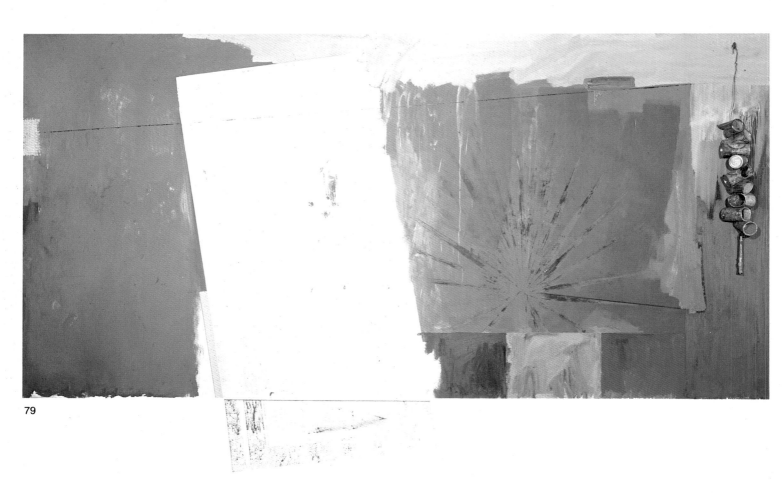

79

including cans, a sponge, an ice tray, and a fork—is pinioned between a ruler and a wax cast of an arm.) *Studio* is a single large canvas to which a smaller rhomboid is attached to complete the studio door. The canvas is not divided geometrically, and, except for rather muddied patches of the primaries, the overall tone is gray and somber. The paint is thicker, especially on the left side, more heavily worked, and often pressed through screens.

Studio 2 is even less giving; here, taken from inside the room, are impressions of four studio windows with the glazing bars forming a large grid of white, through which the view is indistinctly and minimally suggested in grays. Both paintings incorporate rulers as measures of the actual size of parts of the elements. There are other undemonstrative incidents in each work, and the overall impression is one of quiet introspection. Their renewed reticence and the subdued tonality mark a clear change in Johns's work; he is revealing himself through "shunning statement" and has taken us into his workplace to let us see him at work. The concern is no longer with an object depicted in the relative verisimilitude of the *Painted Bronzes*. He is now more laconic, and the real objects are surrogates for his personal experiences. Curiously, this withdrawal places them closer to our real experiences, to our understanding of the everyday, as Johns had explained to Sylvester. The very lack of

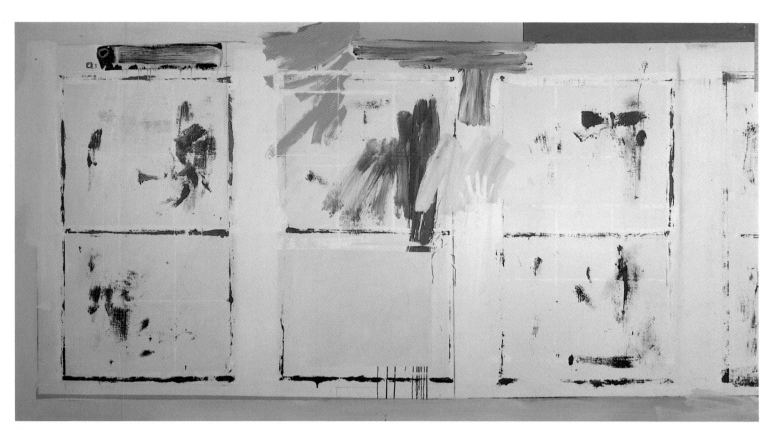

80

79. *Studio*, 1964
Oil on canvas, 88½ x 145½ in.
Whitney Museum of American Art, New York
Gift of the Friends of the Museum

80. *Studio 2*, 1966
Oil on canvas, 70 x 125 in.
Mr. and Mrs. Victor W. Ganz

statement in the *Studio* paintings parallels our everyday experiences, and the lack of defined composition our apprehension of the world. He is closer, too, to his stated ambition of 1959 "to reach the impossibility of sufficient (visual) memory, to transfer from one like object to another the Memory imprint" (quoted by Johns from Marcel Duchamp's *Green Box*).[35] Memory may be explicitly evoked in *Watchman* and *Souvenir*, but it is implicit in the very texture of *Studio* and *Studio 2*. They are, after all, imprinted, and although we cannot draw the simplest parallel (between "imprint" and "memory imprint"), it is clear that we are offered the artist's studio experience. Johns's method here is Proustian and his evocation similarly personal and complex.

Johns was active as printmaker and draftsman during the period that *Voice* developed (1964–67). Richard Field lists twelve prints, and there are also many drawings related to this work. The *Voice* painting harks back, in its composition, to works made before *Studio*. A wire attached to a scraping device suspends a fork and spoon. Below the scraper and its amassed paint is written the partially obscured word *VOICE*. Johns suggests a correspondence between the implements used for filling the mouth and talking. (Has he gone on to the next phase of Duchamp's "memory imprint" project: "Same possibility with sounds"?) Johns then made a litho-

73

81

graph in which only the fork and spoon and wire from the painting appear, and afterward made several larger paintings called
Screen Piece. In these paintings he employed a small photograph, originally made from the first *Voice* painting in order to make the print, on which he had written "Fork should be 7" long." He had enlarged this photograph to life size for the print (the size of a fork being seven inches long); now he enlarged it again for a silkscreen so that the word *Fork* was about seven inches long. The painting operates within this slipping of meaning between the representation of the object and the naming of the object. He is using first the object, then a life-size reproduction of it, and finally a silkscreen of the whole image with the name of the fork enlarged to comply with the written instruction. Each is as real as the next: photograph, object, name, and painting have equal status. Johns's painting, printmaking, and sculpture have also become a unity, each feeding off the other.

The logical conclusion of this process occurred with the *Decoy*

3 chairs

81. *Screen Piece 2*, 1968
Oil on canvas, 72 x 50 in.
Mr. and Mrs. Victor W. Ganz

82. *Decoy*, 1971
Lithograph—edition of 55, 41 x 29 in.
Universal Limited Art Editions, West Islip, New York

prints and paintings of 1971, where the lithograph came first. Johns had developed a great virtuosity with printmaking, discovering and exploiting particular techniques and methods. He has described how the work on the *Decoy* print was transformed by the opportunity to move to an offset proofing press using metal plates; this meant that he could make relatively small changes without moving heavy stones and with increased speed since in offset printing the image is not reversed. "Bypassing that necessity was a new experience for me and, probably, realizing that I was engaged in a thought-process similar to that of painting, I decided to make a painting after the lithograph . . . though not entirely after; I think I began the painting while I was still working on the print."[36]

The two *Decoy* paintings recapitulate the themes of the previous seven years: at the base is a row of images of Johns's sculpture taken from the canceled plates of *1st Etchings*, and in the center an ale can image from a photograph of an actual can with written instructions. Running from top to bottom of the canvas are the

82

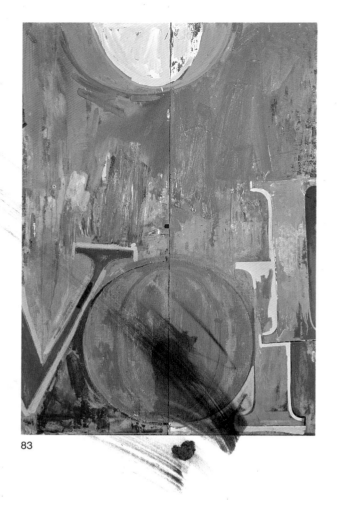

83

names of colors spelled out and turning back upon themselves. In the center bottom is a grommeted hole through the canvas, perhaps to emphasize the flatness of the canvas and the punctured picture plane. (It is reminiscent, too, of Duchamp's holes fired through the *Large Glass*.) *Decoy* is, as always, a precise title; it was. "supposed to draw the birds" and it does deflect attention away from what Johns had been doing elsewhere. It summarizes his printmaking and coincidentally lays the ghost of many of his earlier motifs in painting. It is also, like Charlie Parker's *Ornithology*, "strictly for the birds": amateurs of Johns's vocabulary recognize and appreciate the parts, but overall *Decoy* is less successful as a painting than a print, being a little overloaded with meanings and motifs.

Johns had meanwhile moved in two distinctly separate directions,
83 clearly exemplified by a three-part painting, *Voice 2* (1971), and
84 by a series of works that had begun in 1967 with *Harlem Light*.
85 *Voice 2* was painted as Johns finished reworking the large Dymaxion map. The three panels (ABC) of *Voice 2* can be hung in three different orders, reading from the left (ABC, BCA, or CAB). It is painted as if it were a single canvas that had been wrapped around a cylinder, then unrolled and stretched flat. Each of the canvases can be seen as the beginning, and the edges of the different pairs match, suggesting a continuous space. Johns made *Voice 2* by applying the paint through various kinds of screens, and said: "The patterns of the screens consisted of various sizes and distributions of dots, and, in some cases, squares. The meaning of the

83. *Voice 2*, 1971
Oil and collage on canvas, three panels,
72 x 50 in. each
Kunstmuseum Basel

84. *Harlem Light*, 1967
Oil and collage on canvas, 78 x 172 in.
David Whitney

85

work, to a large extent, depends on the existence of tiny particles within the large work."[37] *Voice 2* is an almost abstract painting; the paint is treated more as a physical than a descriptive medium, a factor of great importance during the next decade.

Two separate chance encounters led Johns in a different direction. On the way to the airport in 1967 he saw a wall in Harlem that had been painted to resemble flagstones. He failed to find it again when he began to make a painting from it: *Harlem Light*. He said to Michael Crichton: "Whatever I do seems artificial and false to me. . . . The trouble is that when you start to work, you can't eliminate your own sophistication. If I could have traced it I would have felt secure I had it right. Because what's interesting to me is the fact that it isn't designed, but taken. It's not mine."[38]

Johns was happy to find something in the world that he could appropriate and invest with nuance; it matters to him, as he says, that what he finds is real and had been made for the maker's pleasure. The flagstones have this character; they do not convey other meanings. Johns's complex "pessimism," his acute sense of his own interaction with the world, makes him question his ability to create an image, whereas taking something already there partly absolves him from this anxiety. The flagstones became the left panel of *Harlem Light*, while on the right and in the center are elements familiar from the Studio paintings: the impressed window, the blocks of primary color, and the rulers. He links the two left-hand panels by a swatch of heavily impastoed black, which is covered over in the flagstone section; this disruption of the image may be a reminder of the fact that we are dealing with a painting and not the wall.

In 1972 Johns talked of another image seen from an automobile: "I was riding in a car, going out to the Hamptons for the weekend, when a car came in the opposite direction. It was covered with

85. *Map* (based on Buckminster Fuller's "Dymaxion Airocean World"), 1967–71 Encaustic and collage on canvas, 186 x 396 in. Museum Ludwig, Cologne

86. *Wall Piece*, 1969 Pencil, graphite, pastel, watercolor, and collage on paper, 27½ x 40 in. Collection of the artist

these marks, but I only saw it for a moment—then it was gone—just a brief glimpse. But I immediately thought that I would use it for my next painting."[39] On several occasions, as we have seen, Johns glimpsed an intense image only for an instant, and he recognized it and then transformed it. At such times he found himself almost helpless—for he could only observe without being able to interfere, to interpose his personality. As in a dream, so in the act of driving or being driven, Johns was placed in the role of the "spy" rather than the watchman. On each of these occasions something ephemeral became abstracted and was given meaning in that change. Johns's memory of a particular, momentary image is the material upon which he works. Neither flagstones nor crosshatching have significance except in Johns's vocabulary and his use of them. They did not mean anything special until Johns recognized the emotional investment by someone, who was not an artist, in an abstract (or nearly abstract) subject. Given that investment they signify something to both maker and the world outside.

With the crosshatching Johns had found an image that would sustain him for almost ten years. He used the image for the first time in *Untitled* (1972), where it is the subject of the left hand of four panels. There, the secondary colors—orange, green, and purple—obey certain rules concerning changes of direction and color. It is difficult to place the edge, and the panel could be imagined to extend in all directions. Johns was dealing with formal

87

87. *Untitled*, 1972
Oil, encaustic, and collage on canvas,
72 x 192 in.
Museum Ludwig, Cologne

88. *Scent*, 1973–74
Oil and encaustic on canvas, 72 x 126¼ in.
Neue Galerie Ludwig, Aachen

89. *End Paper*, 1976
Oil on canvas, 60 x 69½ in.
Philip Johnson

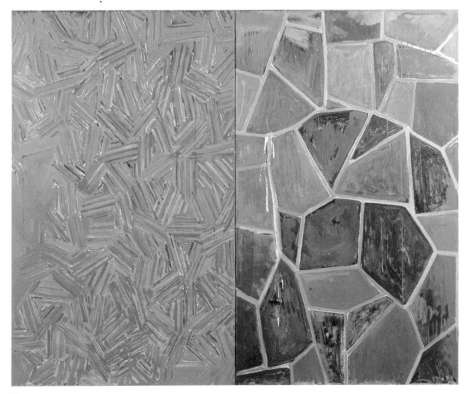

89

problems—particularly, how to indicate the flat surface of the canvas—that would lead him to a renewed and, this time, whole-hearted embrace of the Cubists' analysis of space.

In the right-hand panel of *Untitled* (1972) Johns used casts of body parts again and, in the configuration of hand, foot, sock, and floor, the immediate environment from which they are taken. There are naked buttocks and a naked torso but a pair of feet are in green slingback shoes. Now he attached the parts to wooden stretchers that dissect the canvas area. Each of the parts is personal, each has a specific (unspecified) relation to the other, and while the casts themselves exhibit a great tenderness, there is a saddening sense of almost savage destruction in the work. Johns tried first to affix the casts to canvas flaps, something that is suggested in the *Sketchbook Notes*, but they fell forward. Using wooden battens, which resemble stretcher bars, he dissected both the body and the parts from which paintings are made.

Johns was to rework two of these themes: crosshatching dominated his painting over the next five years, and the panel of casts from *Untitled* (1972) preoccupied him when making prints. During 1973 and 1974 he made a lithographic series of single elements from the panel of casts (in addition to two prints of the whole panel) and two four-part prints of the whole work. This latter went through at least twenty-nine proof stages and was reworked by Johns principally "to balance foreground and background." He also embossed the outline of each panel on the following panel, which encourages the sense of continuity between the separate panels.

In 1973 Johns began a collaboration with Samuel Beckett, which resulted in the book *Foirades/Fizzles*. This contains five stories by Beckett and thirty-three etchings by Johns. It was thought, perhaps unwisely, that both men had made a similar, bleakly realistic account of the world. In any event, they did not communicate similarly. It is clear, and this should be emphasized, that Johns works with a group of visual metaphors that may give the appearance of having literary ancestors, but are more sparse and rigorous than even those in Beckett's etiolated prose. Neither man moved from his own territory, and the results could be compared to reading a parallel text: it is essential to read both parts together to have an understanding of their collaboration. Johns used (reworking all the parts) the *Untitled* (1972) image, presenting, among other readings of the whole image, four variant orders of the panels, in the style of *Voice 2*. He offered a version in words of the names (in French and English) of the parts of the cast panel and made his end papers from a combination of the flagstones and hatching. (This is also the subject of a painting, *End Paper* of 1976.) The images do not illustrate Beckett's text (nor do Beckett's tales describe them); rather, they are, in Geelhaar's words, "united by a strange, inner affinity."

In 1962 Johns had returned, with *Zone*, to using encaustic and oil paint in the same work, something that he copied in printmaking by having glossy and mat inks. This same combination of encaustic with oil was one of the elements of *Scent* (1973-74). Here, in a relatively large format, Johns established the ground rules for his

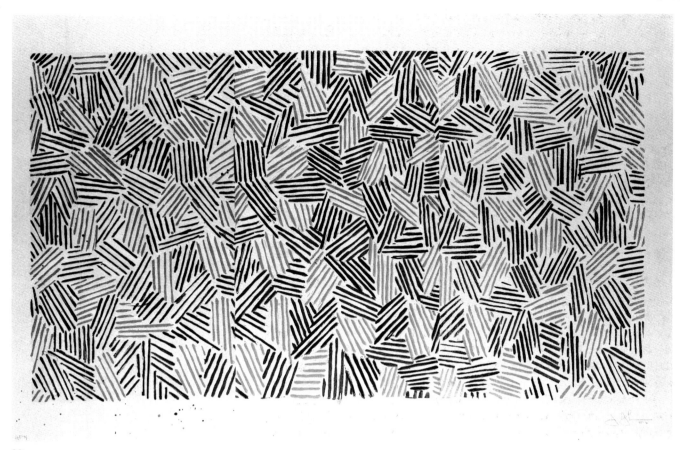

90

crosshatched paintings. *Scent* is divided into nine vertical panels: three canvases, each divided into three by drawn lines. As Crichton explained, the left and right sections are identical, as are the third and fourth and the sixth and seventh. We could label them (from left to right, ABC, CDE, EFA) and rearrange them (CDE, EFA, ABC), for example, so that the edges read one to another. Johns chose a title used by both Rauschenberg and Pollock (*Scent* is known as Pollock's last painting, and Johns's reference may be an ironic nod to the history of art). In Pollock's last works we are offered an apparently seamless overall web out of which emerges a specific presence, emotional or representational. Johns's *Scent* offers an equivalent complexity and, moreover, is based on the real world. Its alloverness is illusory, but it does continue the debate over surface, edge, and picture plane that has long sustained modernism. Johns elects himself, by using that title, as a proponent of those questions.

90. *Scent*, 1975–76
Lithograph, linocut, and woodcut—edition of 42, 31¾ x 47 in.
Universal Limited Art Editions, West Islip, New York

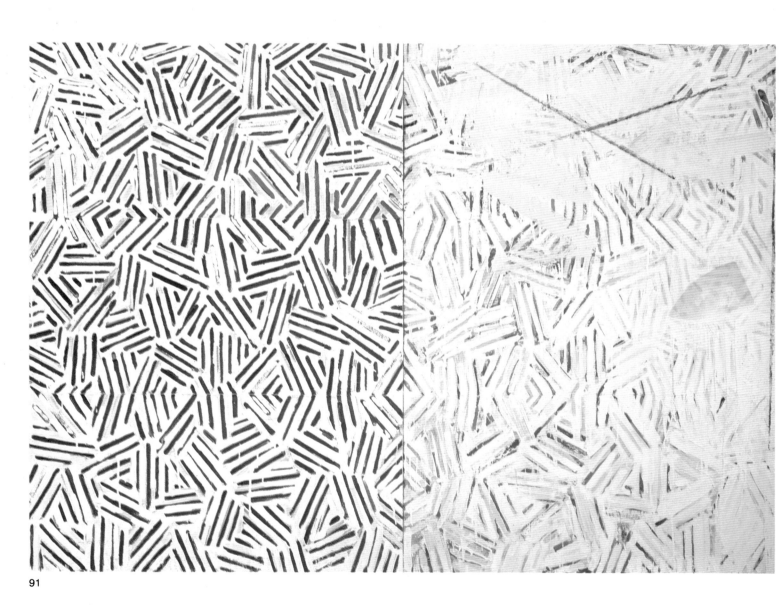

91

Crosshatching and the History of Art, 1972–1977

Johns had a small house in upper New York State, which he used occasionally. In 1973 he decided to make that his home and moved there; he built a studio and "winterized" it. This marked a further withdrawal and placed him "in retreat" from the growing pressures upon him of the downtown art world in SoHo and, later, the East Village. The house is small—it has been well described in Michael Crichton's monograph—and Johns's studio is much smaller than before. Crichton talked about how the house is enclosed, almost closed in upon itself, for the views are all on one side—to the woods. Johns's art also adopts this voice, like dialogues conducted by one person, curiously reminiscent of Wittgenstein's written discourse. The work is concerned, again, with particular cruxes in the history of art and could be viewed as another part of Johns's desire to learn. The first pictures that follow *Scent* refer to Surrealism, one of whose motivations had been the dream.

The Surrealists had played a sophisticated game in which each participant would draw part of a figure on a section of folded paper, without seeing the other contributions. (*Cadavre exquis* or "exquisite corpse" was named after the first version of the game, played with words.) Johns revivified the Surrealist "exquisite corpse": the title *Corpse and Mirror* is therefore relatively simple 91 to understand. Johns began by painting the "corpse" on the three left-hand sections, without reference to each other; the joins between the sections coincide as they would on a conventional exquisite corpse, but the other edges do not (A to B and B to C in a vertical plane only). This left-hand panel is painted in oil. The right-hand triple panel is a mirror of it, as can be easily seen by comparing the central vertical join. Painted in encaustic with collaged elements of newspaper under the surface, the right-hand panel is technically similar to Johns's earlier encaustic paintings. There are other incidents, however: the mark left by an iron (a tool used in encaustic painting), a large scored cross, and a heavily impastoed zigzag of pink paint, none of which appears on the left. Richard Field has suggested that these marks above the surface of the hatching establish the surface of the "mirror" and that Johns is playing with a series of subtle spatial shifts. Field likens the cross

91. *Corpse and Mirror*, 1974
Oil, encaustic, and collage on canvas,
50 x 68⅛ in.
Mr. and Mrs. Victor W. Ganz

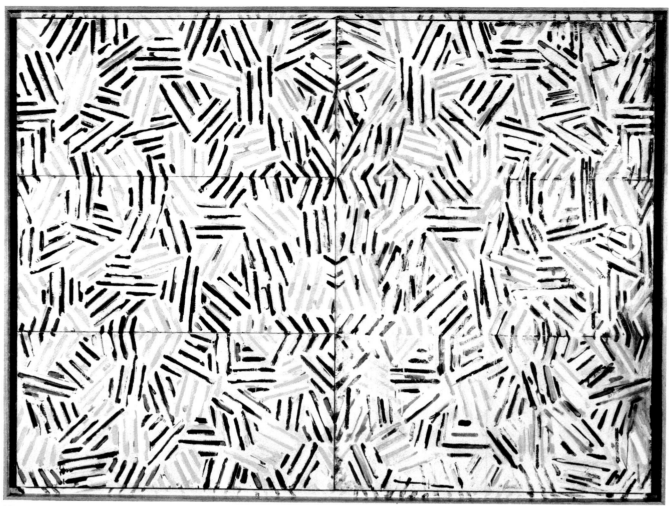

92

to a cancellation mark, which is used in printmaking to mark the end of a printing. It appears, for example, in the *Untitled (Skull)* print of 1973, where Johns cancels his own signature: might he perhaps have been recalling that image? In the aquatint and lithograph after the *Corpse and Mirror* image the cross remains, and in one the iron shape is replaced by a can imprint. The mark is reminiscent, too, of the scissors that connect the glider and the chocolate grinder in Duchamp's *Large Glass*. Magical, but frustrated, unconsummated, and thereby onanistic sexuality is the subject of Duchamp's work; Johns could be making similar references here. We could also speculate, since Johns has told us that his work is psychologically loaded, that the subject of the mirror is related to his renewed interest in the development of the psyche. Jacques Lacan's reworking of Freud, especially his essay on the mirror stage in the child, is particularly suggestive.[40]

92 Johns's second version of *Corpse and Mirror* (1974–75) was made in primary colors, in oil on canvas. The left-hand panel is constructed from three separate canvases, as if to underline the conceptual process of making an exquisite corpse. The panel on the right is more loosely painted, particularly toward the right-hand edge, where he has left the mark of a can used for brushes.

92. *Corpse and Mirror II*, 1974–75
Oil on canvas with painted frame,
57⅝ x 75¼ in.
Collection of the artist
On loan to The Art Institute of Chicago

93. *The Barber's Tree*, 1975
Encaustic and collage on canvas,
34¼ x 54¼ in.
Neue Galerie Ludwig, Aachen

94. *The Dutch Wives*, 1975
Encaustic and collage on canvas,
51¾ x 71 in.
Private collection

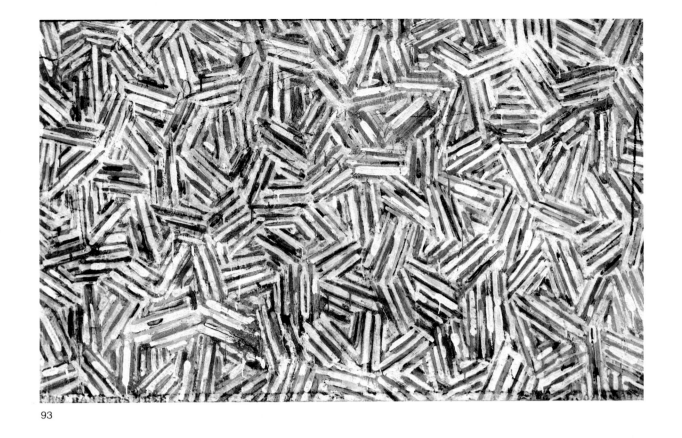

93

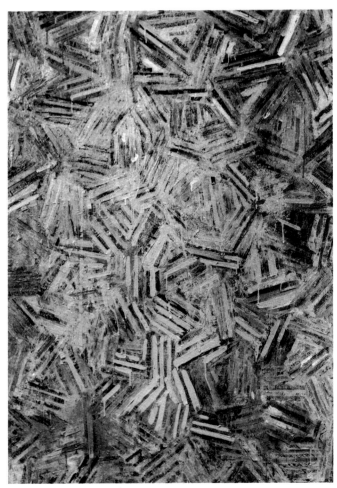

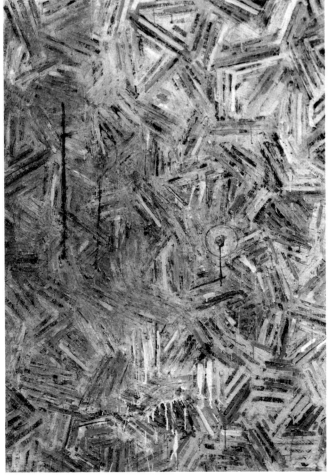

94

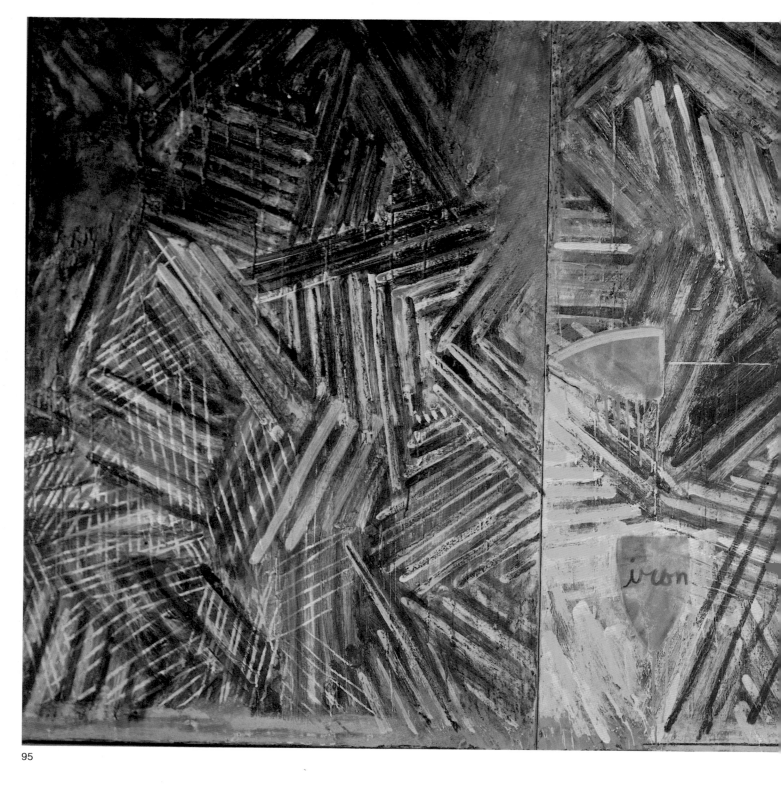

95

The paint extends over the edges and onto the frame, suggesting that the canvas area is part of a larger image and that the picture plane has been forced forward for explication and analysis.

With *Barber's Tree* and *The Dutch Wives* (both 1975) Johns again took a subject from the world outside, subjects not normally connected with art. The Mexican barber paints his sign on a tree: Johns saw a photograph of one doing so in *National Geographic*. One definition of a "Dutch wife" is a board, with a hole, used by

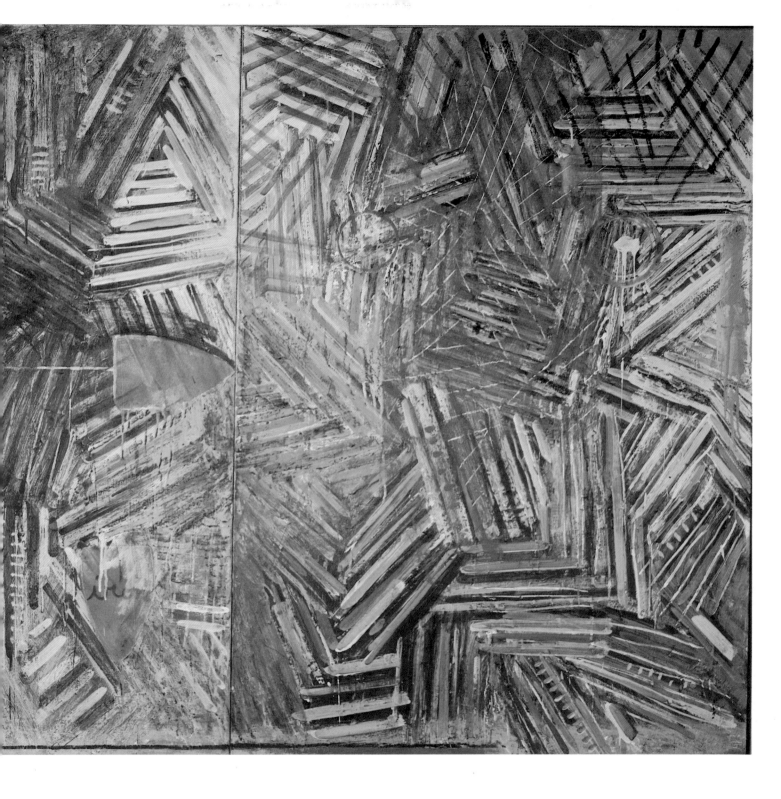

95. *Weeping Women*, 1975
Encaustic and collage on canvas,
50 x 102¼ in.
Mr. and Mrs. S. I. Newhouse, Jr.

sailors as a surrogate for a woman. The barber's tree may be, as
Crichton suggested, another example of Johns's interest in lifting
an image from reality, in the fashion of the flagstones or the
hatching. He would also enjoy the coincidence of a primitive artist
making an image superficially similar to his own and the idea of a
sign changing status to become a work of art. Semiological analysis
would be in order.

The two-panel *Dutch Wives* painting reconstitutes fully two ele-

ments used in the encaustic paintings of the late 1950s: collaged newspapers and a predominantly gray tonality. There is an image and its counterpart, but while all four edges of the two canvases are alike (even to the extent of the newspaper collage being exactly repeated), the center of each canvas is different and distinct. The strokes of the left panel form a shape that could be a figure, while on the right they are indistinct, splashed and scored with long black lines. The right also has the mark of the paint can, itself encircled clumsily in red and, in the center, a more defined phallic shape from which emerges a drip of gray paint. A simple reading would be that we are looking at the image of a woman on the left and her substitute, the Dutch wife, on the right (like *Decoy*, it stands for). Also, the wife on the left might be a figure drawn from other art, and we could infer that this is the artist's Dutch wife.

95 *Weeping Women* (1975), a triptych painted in subdued primary colors, is, as Rosalind Krauss has written, drawn from Picasso's paintings of nudes in the proto-Cubist period of 1907–9. If one posits that the three women exist in Johns's canvases, the figures are suggested by the insistent long strokes and by the fading of the strokes toward the edges of the panels. They obey that characteristic compositional device of Cubist painting, constructed from the center and opening out on either side of a notional spine drawn down the canvas. Picasso's images are double-hatched, with a secondary thinner hatching used to delineate forms. Johns does this too, but his hatching also obeys his own rules.

It is interesting to apply Daniel Henry Kahnweiler's description of Picasso's second phase of work on the *Demoiselles d'Avignon* to this painting by Johns; he wrote: ". . . the color is not spread smoothly over the canvas, but dragged in parallel strokes aiming at creating shape, not by light and shade . . . but by drawing, by the direction of the actual strokes of paint. Artists had imitated Cézanne's subjects and copied the appearance of his pictures, without comprehending their whys and wherefores. Now at last he was understood."[41]

Johns has combined several other aspects of Picasso's work: the title *Weeping Woman* did not appear until the 1930s, while the impressions of the iron are strongly reminiscent of the collaged breasts in the *Femme en chemise assise dans un fauteuil* of 1913, owned by Johns's friends and collectors Mr. and Mrs. Victor Ganz. The right-hand panel introduces the paintbrush-can mark as breasts and qualifies the surface. Johns used large strokes in *Weeping Women*, and, perhaps because of the subject matter, did not seem preoccupied with the inversion and mirroring that abound in the other works of this date.

These crosshatched works were the most recent included in a major retrospective of Johns's work that toured the world in 1977 and 1978. While Johns was often reverently received, his work was, not unexpectedly, criticized by Hilton Kramer and other critics. Robert Hughes in *Time* said that the show revealed Johns as "not the Leonardesque genius we have all been conditioned to expect."[42] They regarded the recent work as a falling-off, a reduction in Johns's now legendary power to transform ordinary materials into crystalline icons. The last work in the show, *End Paper*, began to

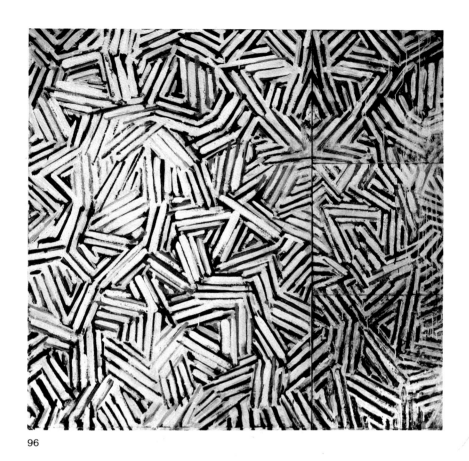

96

look like an endgame (to borrow a title from Beckett), an impasse from which he would find it difficult to escape.

A smaller square canvas, *Untitled* (1975), which was not in the 96 retrospective, contained the germ for a new group of untitled works. As Barbara Rose has shown, Johns used a single square of the image to generate variations by inversion, rotation, and reversal as well as by mirroring. The painting retains its apparent allover integrity while at the same time offering clues as to its construction. Johns's prints of this subject offer us each of these clues in turn. His operating procedures dominate these works, whose characteristic, limpid beauty is astonishing. Instead of offering us levels of psychological and similar material to unravel and elucidate, Johns provides the complex processes of unfolding the picture's own surface. It looks like a period of merely treading water. We may be misled, however, since the paintings of 1963–66 looked less interesting than the Flags and similar subjects soon after they were made, but were the generators for major works of the late 1960s.

96. *Untitled*, 1975
Oil and encaustic on canvas, 50⅛ x 50⅛ in.
Eli and Edythe L. Broad

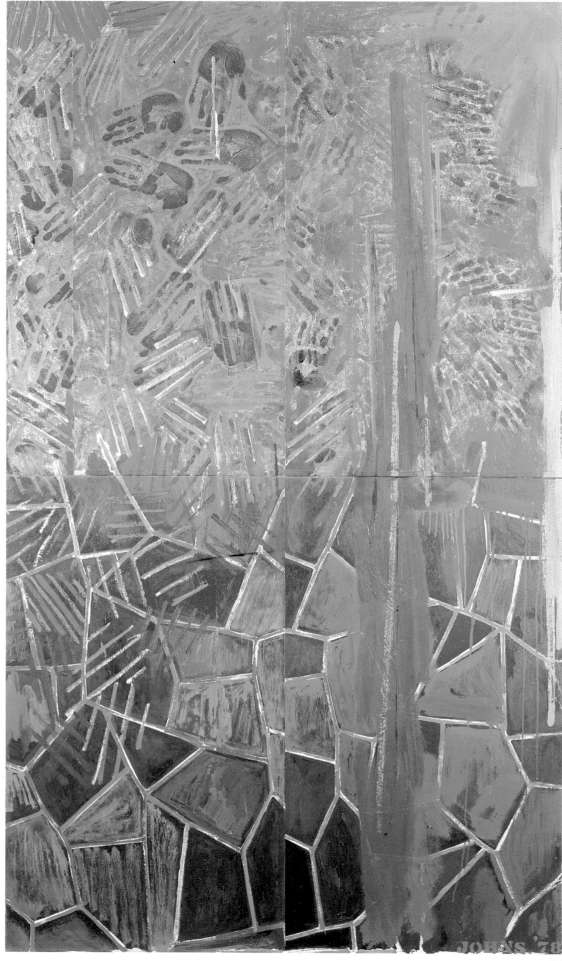

4 The Voice Seems to Come from Some Other Source, 1977–1984

Travel is useful, it exercises the imagination. All the rest is disappointment and fatigue. Our journey is entirely imaginary. That is its strength.

It goes from life to death. People, animals, cities, things, all are imagined. It's a novel, just a fictitious narrative. . . .

And besides, in the first place, anyone can do as much. You just have to close your eyes.

It's on the other side of life.

Louis Ferdinand Céline, *Journey to the End of the Night*

Johns showed few paintings in the seven years following his retrospective. They appeared in ones and twos in group exhibitions: in November 1978 he showed *Céline* at Leo Castelli (it was bought by the Kunstmuseum Basel); in 1979 six paintings, including *Usuyuki* and *Céline*, were in the Corcoran Biennial; in 1981 he showed three paintings entitled *Tantric Detail*; and two works were included in the 1983 Whitney Biennial. An exhibition of ten years of drawings (1970–80) was shown in January 1981 at the Castelli gallery on West Broadway. Fourteen works made since 1978 were exhibited together for the first time in January 1984 at Castelli's Greene Street gallery.

Céline (1978) must stand as the beginning of the new body of work. Jeff Perrone has argued that we can regard this as a psychologically explicit image that incorporates motifs that acknowledge a masculine castration complex. Louis Ferdinand Céline was a French author best known for his novels *Journey to the End of the Night* and *Death on the Installment Plan*, both read by Johns around the time of making the work. The novels are nihilistic, bleak, and violent; their concern is the dissipation of life in extremis, and, as a corollary, an understanding of the amorality of the creative faculty. The images used in the painting are versions of the hatchings and flagstones, but they are painted in brutish colors and slip across the grid. The image of the arm (found in *Land's End* of 1963 and other works) is repeated twice (mirrored above and below the central division). *Céline* shows that two other parts of Johns's vocabulary, the flagstones and hatchings, can also be made to mirror each other and may invade each other with impunity.

97. *Céline*, 1978
Oil on canvas, 85⅝ x 48¾ in.
Kunstmuseum Basel

Céline is therefore like a vertical version of *End Paper*, but here one image bleeds into the other, and, in addition, the artist's hand-prints are impressed on it. Johns inserts himself into this painting in the way that the viewer was invited to take part in earlier works by lifting flaps to reveal casts. In doing so Johns reveals himself, or at least a mirror image of himself, more clearly than ever before, and these revelations become the subject of the paintings that follow.

The drawings shown at Castelli's gallery in 1981 offered clues and, in some cases, a partial explanation of the subject matter of the paintings that would follow. Several drawings were entitled *Cicada*: a cicada is a transparent-winged insect, and the drawings were executed in transparent inks on drafting film, which produced an iridescent surface. They are bilaterally symmetrical and you can imagine being able to look at both front and back of the sheet. The surface may be gridded—i.e., broken up into areas like the earlier works—but it has assumed the character of an insect's wing; it is a carrier of the patterning and is not penetrated by objects.

99 At the base of one of these 1979 drawings Johns has left visible, uncharacteristically, a group of notes for suggested subjects. They indicate a desire to break away from the crosshatching and to introduce other subjects into the work. He draws the cicada and, beside it, the testicles and base of an erect phallus. Nearby is a death's head and a reference to "The Pope at Auschwitz."

While I was talking to Johns about *Dancers on a Plane* (1980), he showed me a sketchbook page that revealed his interest in the image of Pope John Paul II at Auschwitz: a press photograph of the incident with a warning sign of the skull and crossbones in the background. (The pope, a Pole, had made a visit to the concentration camp, a grim reminder of the Holocaust and its effects on his countrymen and an ironic incident in the light of current repressions in Poland.) Johns had found, in the world portrayed by the media, in an event of profound humanitarian significance, an image that "belonged" to him and that he could make stand for his concerns. The skull had first appeared in Johns's work in drawings

98 of 1962–65 and most prominently in *Arrive/Depart* of 1963–64, a painting whose elements are now, with hindsight, more clearly legible. This work incorporates a hand-print plus marks left by cans and by Duchamp's *Female Figleaf* sculpture. References to the surface are made both in the way the paint is applied through screens and in the warning sticker for glass in the center: this contains the warning "Handle with Care" and could be compared to the avalanche sign in later works.

Johns made two versions of *Dancers on a Plane*. (This title is inscribed in mirrored writing at the base of the canvas; in the gray version there also appears the subject of the picture, what it is about: "Merce Cunningham" is spelled out. Both inscriptions begin to the right of the median line of the canvas.) Johns emphasizes here the double-sided nature of the support—as in the *Cicada* drawings, he creates the illusion that *Dancers on a Plane* could be read from behind. He expressed interest in the paradox of showing dance—a three-dimensional activity in time—on a two-dimen-

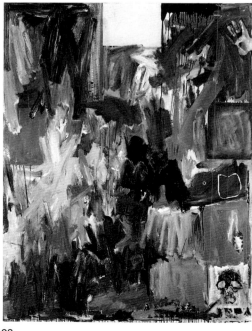

98

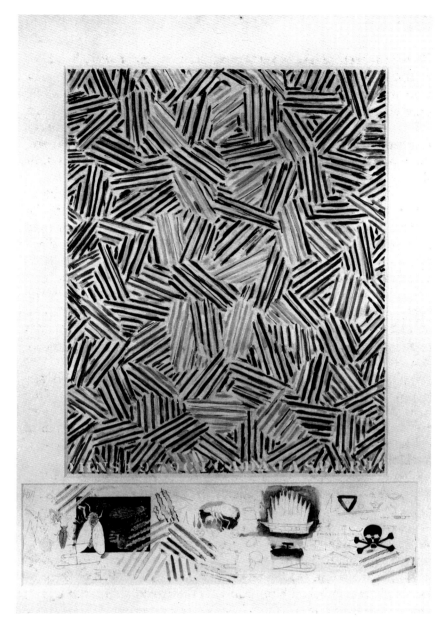

99

98. *Arrive/Depart*, 1963–64
Oil on canvas, 68 x 51½ in.
Bayerische Staatsgemaldesammlungen,
Munich

99. *Cicada*, 1979
Watercolor and pencil on paper, 43 x 28¾ in.
Collection of the artist

sional surface. Johns established rules for the directions and colors of his brushstrokes in the first painting and adhered to them. The canvas is divided down the center and into four approximately equal horizontal areas. The disposition of the hatching strokes and the colors can change on these horizontal divisions. The changes are as follows: at the first, both direction and color change; at the second, the direction is constant but the color changes; at the third, the color is constant but the direction of the strokes changes. You must posit the fourth by assuming that top and bottom edges are joined when neither direction nor color changes. These rules were relaxed somewhat in the second version. The first was painted so that it lacked emphases, the second incorporates several. 102

Johns had not been able to successfully include the phallus and testicles into the first canvas; they are shown in the frame of the second, where they appear divided between top and bottom. The dotted line on the central division in this later work was suggested

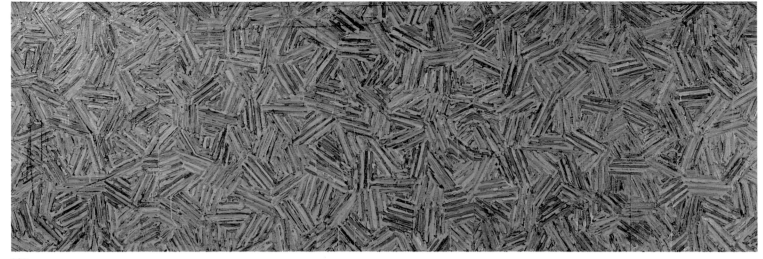

100

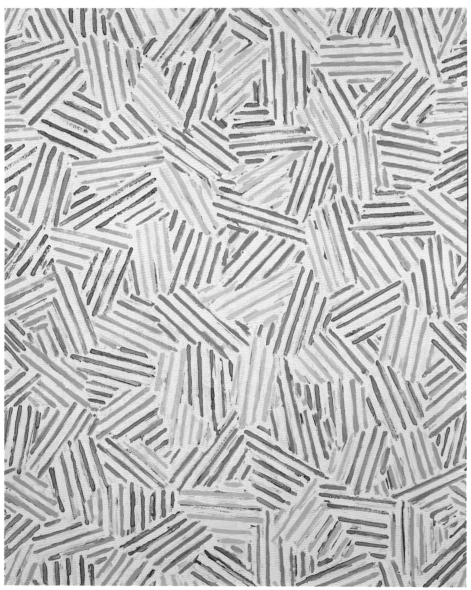

100. *Untitled (E. G. Siedensticker)*, 1979
Encaustic and collage on canvas, 30 x 90 in.
Robert and Jane Meyerhoff

101. *Cicada*, 1979
Oil on canvas, 50 x 37⅞ in.
Private collection

102. *Dancers on a Plane*, 1980
Oil on canvas with bronze frame,
78¾ x 63¾ in.
Tate Gallery, London

101

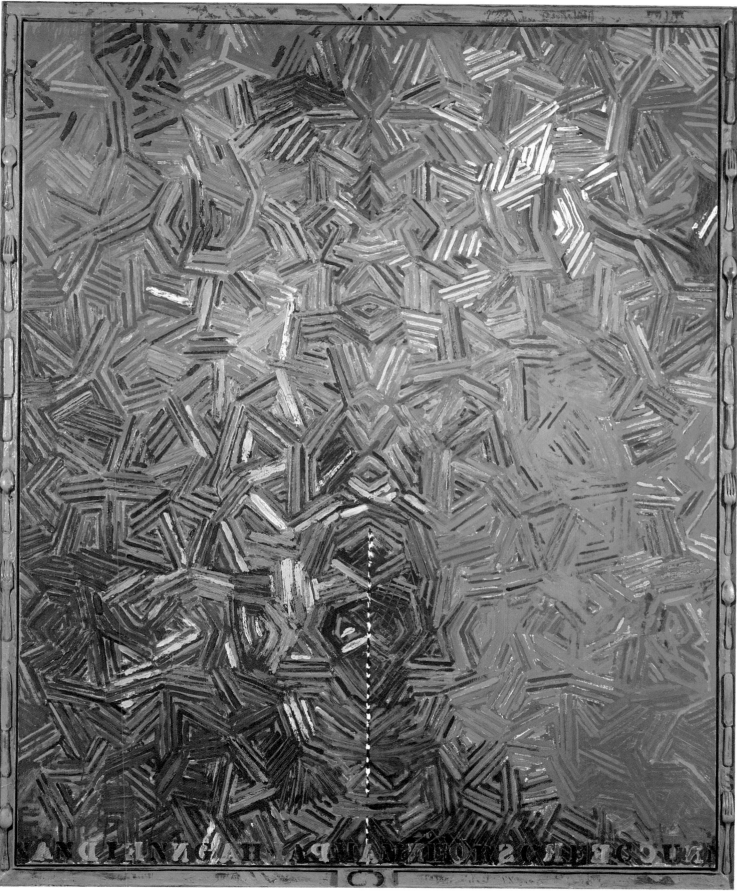

103

104

to Johns by Tantric illustrations of jewelry, including the bones and skulls worn by gods. He has said that the Western symbols of eating, of ingestion (compare his earlier works) in the frame are similar to the multihanded images of the gods in Nepalese paintings. Johns said of the work's relationship to this source:

Seeing a thing can sometimes trigger the mind to make another thing. In some instances the new work may include, as a sort of subject matter, references to the thing that was seen. And, because works of painting tend to share many aspects, working itself may initiate memories of other works. Naming or painting these ghosts sometimes seems a way to stop their nagging.[43]

103-5 The skull is also apparent in the interstices of the three *Tantric Detail* paintings of 1980 and '81. Johns had developed the hatchings to reveal, with great subtlety, layered and interacting picture planes. In the *Tantric Detail* paintings he went farther and undermined this by suggesting that the planes, unlike those in the *Cicada* drawings, are not transparent. Objects can only be seen between the planes and can be partially hidden by them. This clear exposition of the images of skull, phallus, and testicles is a development

103. *Tantric Detail I*, 1980
Oil on canvas, 50⅛ x 34⅛ in.
Private collection

104. *Tantric Detail II*, 1981
Oil on canvas, 50⅛ x 34⅛ in.
Private collection

105. *Tantric Detail III*, 1981
Oil on canvas, 50⅛ x 34⅛ in.
Private collection

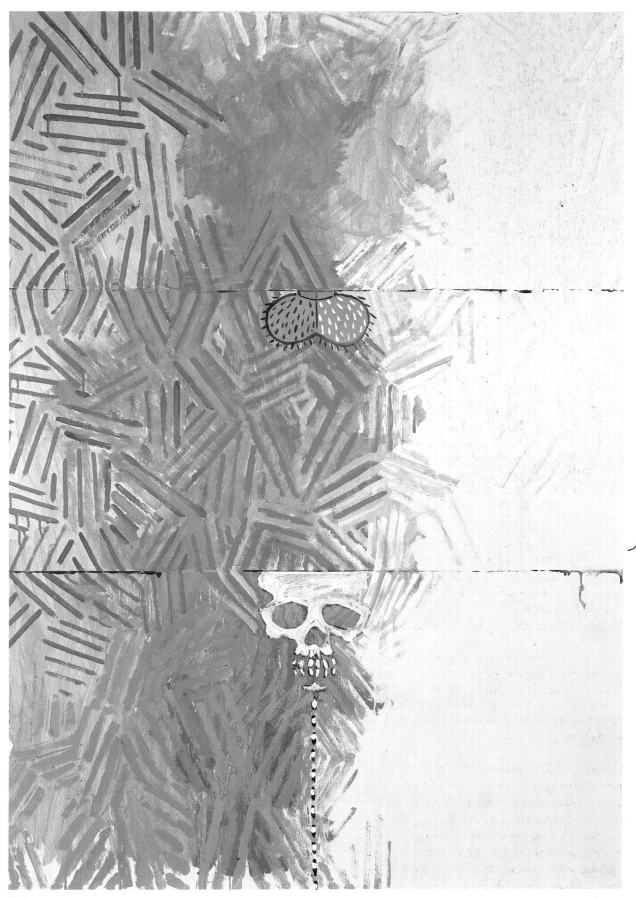

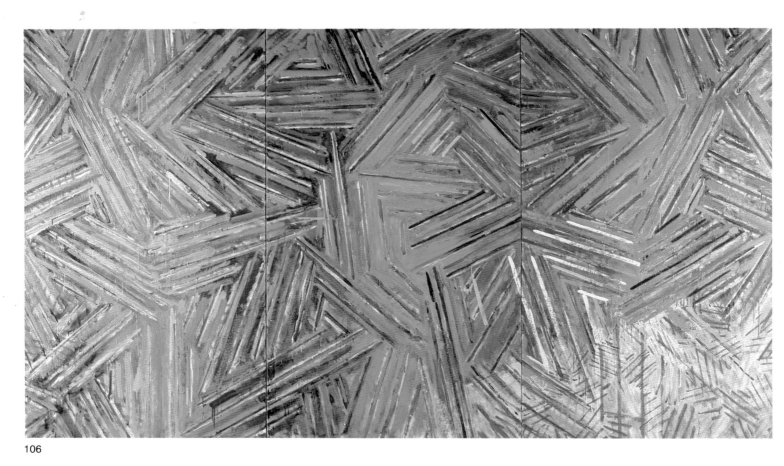

106

of those hinted at in the drawings and veiled in other paintings that immediately precede these. They stand halfway between the beginnings of this release of "the nagging," and the most recent works, where the apparatus of doubt is fully displayed.

Edvard Munch (1863–1944), an artist whose expressively personal canvases seem distant from those by Johns, nevertheless provided him with the subject for the two paintings of 1981 entitled *Between the Clock and the Bed* and a third of 1982–83. Johns had been struck by the coincidence between the quilting on the bed in Munch's self-portrait of the same title and his own crosshatchings. Munch's work shows the artist standing in a room, between a faceless clock (time) and bed (death/sleep), with his studio full of paintings behind him. It is not an image of self-pity, but it is desperate nevertheless. Johns took the hatched form of the figures from *Weeping Women* and offered an abstracted version of Munch's image, which suggests a similar desperation. Johns painted the third version in grays and blacks, except for the area of the "bed," which is in the secondaries. The changes of scale of the strokes as they cross the canvas delineate the subject but remain stubbornly abstract. These images have the same complex relationship to Munch's picture that *Weeping Women* did to Picasso's. The lithographs and monotypes of the Savarin can that explicitly allude to Munch were made at the same time.

Johns was possibly drawn back to the subject of his own working place by the Munch painting. In the later painting *In the Studio*

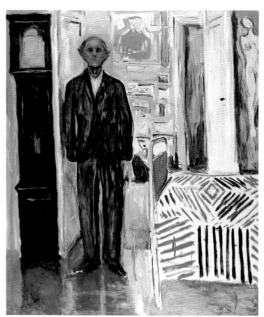

107

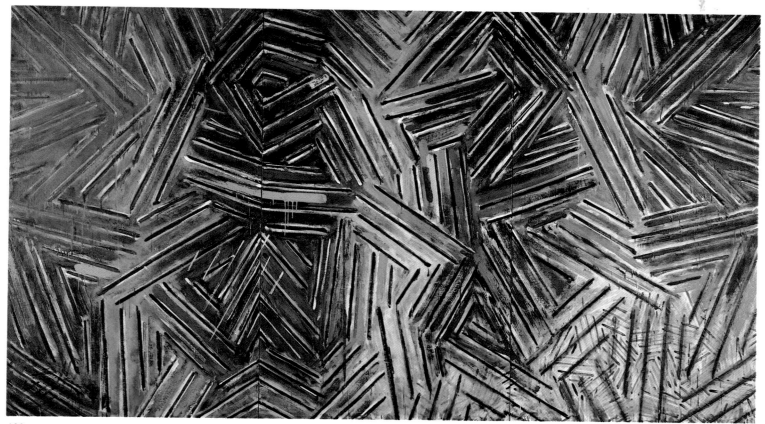

108

110, 6

111, p. 2

106. *Between the Clock and the Bed*, 1981
Encaustic on canvas, 72⅛ x 126⅜ in.
The Museum of Modern Art, New York
Gift of Agnes Gund Saalfield

107. Edvard Munch.
Between the Clock and the Bed, c. 1949
Oil on canvas, 59 1/16 x 47¼ in.
Munchmuseet, Oslo

108. *Between the Clock and the Bed*,
1982–83
Encaustic on canvas, 72 x 126⅛ in.
Sydney and Frances Lewis Foundation,
Richmond

(1982) his practice as an artist is further revealed and dissected.
The picture plane is made to recede by a drawn quadrilateral that
is disrupted by a projecting stick that casts shadows. (Other works
by Johns had been drawn but only partially completed and then
almost wholly obliterated by dribbled encaustic.) There is a cast of
a child's arm encased in a flagstone skin of colors; this is repeated
in a "drawing" that is "pinned" to the canvas by "nails" in the
style Braque used in his Cubist still lifes. The whole work could
represent a still life or a corner of the studio, but the references
that Johns makes in his juxtapositions of reality and artifice are
more to the artist's own creative faculties than to an everyday
world. The artist's materials are in various stages of ingestion and
presentation. Materials and ideas are given a similar status; they
are interwoven and we must assume complex interrelationships.
For example, the wax arm is made from the same material as
encaustic, and the color in the arm appears to be embedded; the
arm is that of a child and the other images in the work are crucial
parts of Johns's iconography.

In four more recent pictures—*Perilous Night, Untitled* (1983),
Racing Thoughts, and *Ventriloquist*, Johns is cinematic in the pre-
sentation of his thoughts: we could imagine that this sort of mon-
tage of images is, like dreaming, a subversive activity, where the
"unthinkable" is permitted. All four have elements in common, all
are uncomfortable in content and palette, and all have a brooding
pessimism hanging over them. They are divided centrally, and the

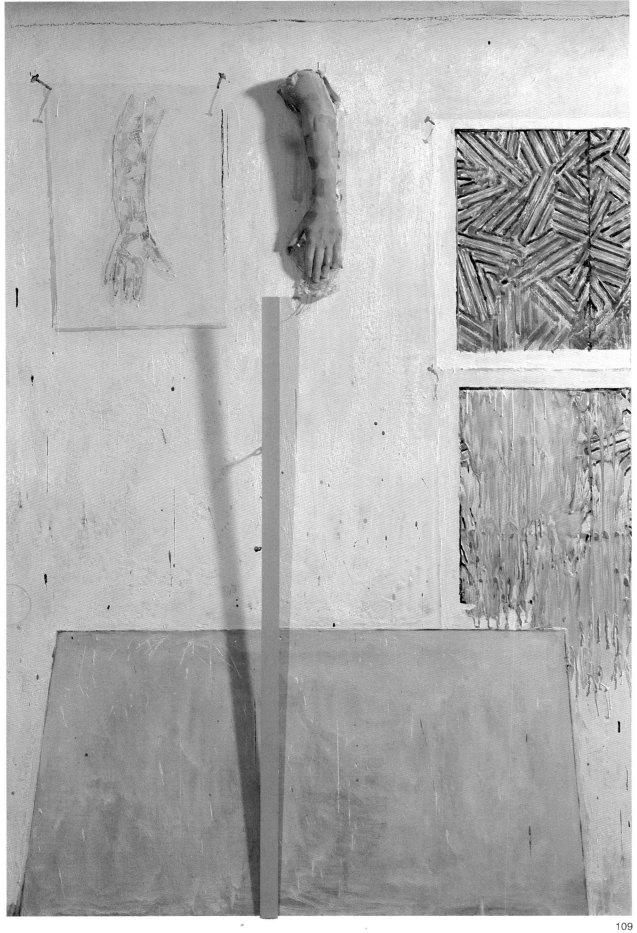

109

102

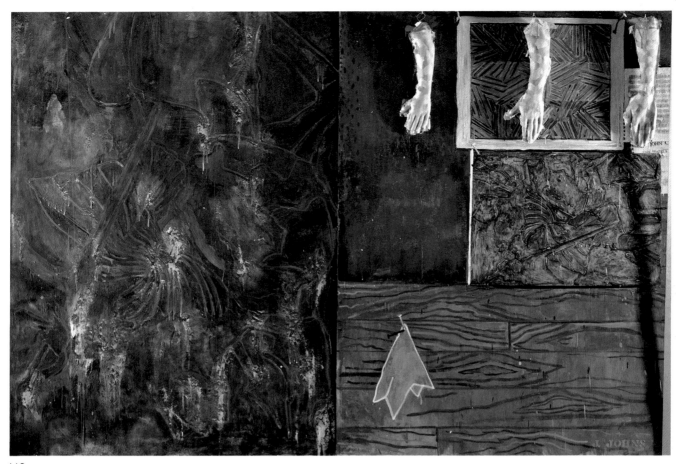

110

109. *In the Studio*, 1982
Encaustic on canvas with objects,
72 x 48 x 4 in.
Private collection

110. *Perilous Night*, 1982
Encaustic on canvas with objects,
67 x 96 x 5 in.
Robert and Jane Meyerhoff

left half of each (except *Ventriloquist*) shows a different treatment of part of an image from Matthias Grünewald's Isenheim altarpiece (c. 1515). The knight from the altarpiece's predella panel is easily distinguished in *Perilous Night*. In the other works the overlaying of crosshatching in red or green and of wood-graining combined with crosshatching obscures the image.

Perilous Night is also the title of a piece of music composed by John Cage; it appears as a silkscreen made from the score that is placed under a cast arm in Johns's painting of the same name. (The words "perilous night" are taken from a line in "The Star-Spangled Banner.") In this work Johns has used casts from the same child's arm at three different ages, an image taken from drawings, and a second version of the Grünewald detail reduced, reversed, and turned ninety degrees. He has "pinned" a "handkerchief" to a "paling" below these images.

In *Untitled* (1983), *Racing Thoughts*, and *Ventriloquist*, Johns offers us his view from his bath. Some elements in these paintings (faucets, linen basket, door, and a Barnett Newman print) are correctly disposed: this is the view you would get while taking a bath in his tub. Others, like an iron-on transfer of the Mona Lisa and what appear to be corduroy pants, are represented as if pinned, taped, or hanging. In *Untitled* (1983) a cast of an arm hangs from a hook over a collage of a page from the *New York Times*; in *Racing Thoughts* a painted nail with long shadows suggests the

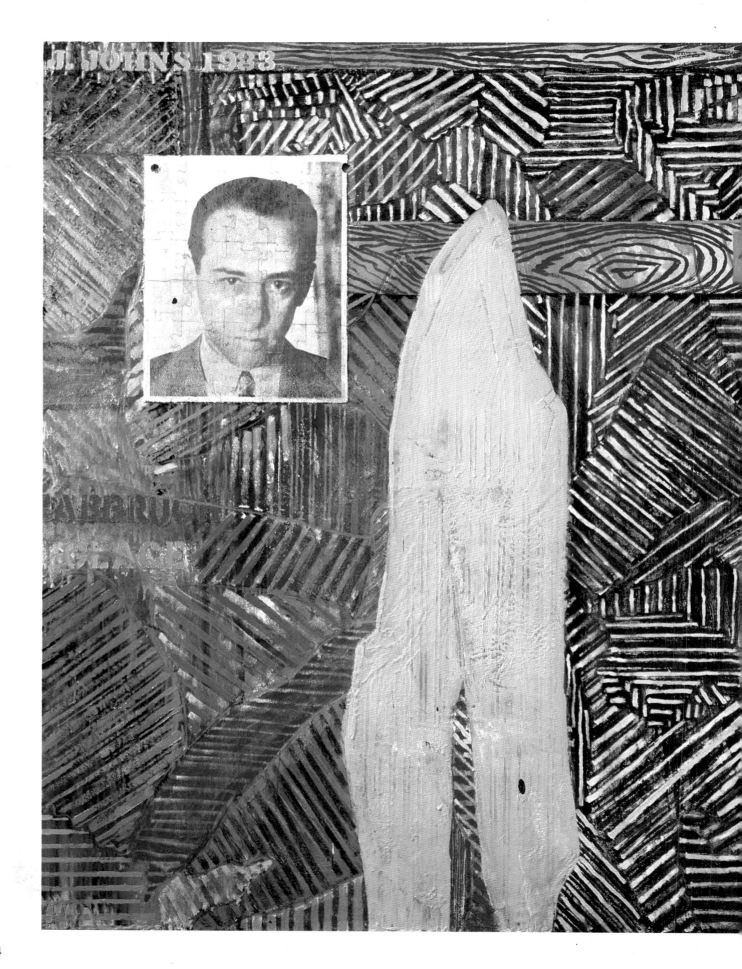

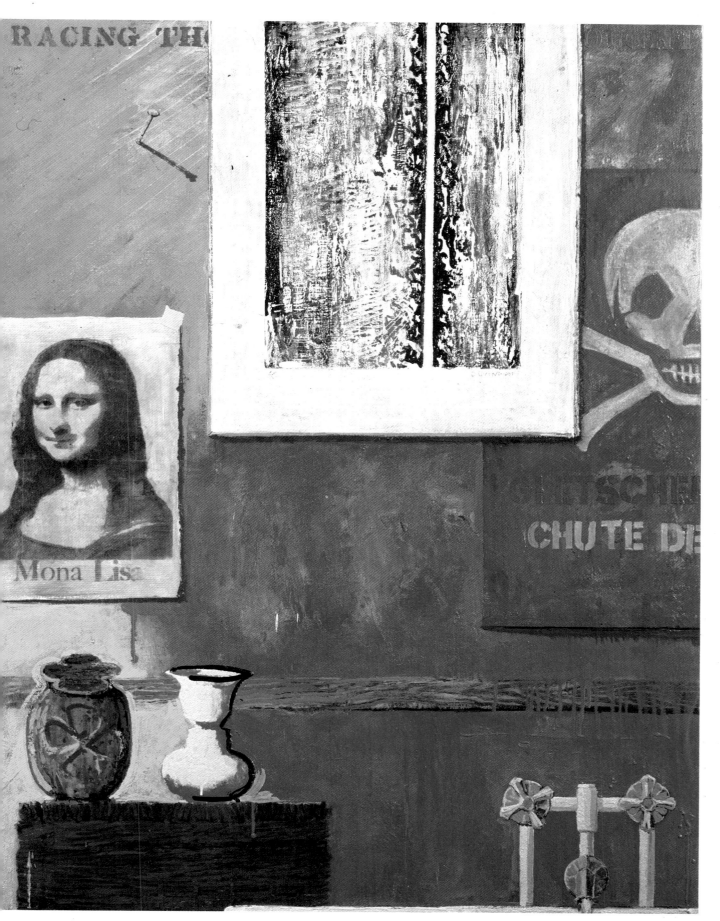

arm's possible absence. But, as the title of one of the works suggests, Johns is projecting his current preoccupations upon his environment. Each of the elements has a specific importance for him: George Ohr's pottery; a German porcelain vase with the profiles of Queen Elizabeth and Prince Philip produced for her Silver Jubilee in 1977 (which recall his *Cup 2/Cups 4 Picasso* drawings and prints); his dealer, Leo Castelli, in the form of a jigsaw puzzle made from a 1946 photograph; a Swiss avalanche warning sign; and the submerged Grünewald image. Paradoxically, these works are full of images "seen" with the eyes closed, images of thoughts of things "that the mind already knows." They are personal and revelatory both of Johns and, through their insistent pessimism, of the human condition.

Ventriloquist pursues literally the notion of things not seen, for the image taped over the layered background is of two American flags, painted predominantly in green and black. (The image itself comes from Johns's poster to celebrate fifty years of the Whitney Museum of American Art, which shows flags with forty-eight and fifty stars, implying the growth of both America and American art since the Whitney's foundation.) Johns had used these colors on an earlier occasion to make a flag. We can see the colors of red, white, and blue only by looking closely at the image and then closing our eyes, when the "correct" colors appear as a retinal afterimage, an image paradoxically "looked at and not seen." Johns thus produces another gambit in his game of optical veracity as he manipulates the tenuous links between the painted and the perceived world.

But *Ventriloquist* is also about something else; it is, as the dictionary defines it, a situation "where the voice seems to come from some other source" and where Johns, using other's voices, gathers around him his Americanness. As the original Whitney poster image celebrates that institution, so *Ventriloquist* offers an alternative tradition. On the left Johns has partially submerged the image of Melville's Moby Dick taken from an engraving by Barry Moser. (Johns liked the engraving very much and tried to buy a copy.) Floating above these, but still below the surface on which the flags are "taped," are George Ohr's pots. On the right there is a painstaking rendition of the faucets, basket, and the porcelain pot, and the illusionistic Braquian nail. Above them the Barnett Newman lithograph is reversed, mirrored, either a reflection of itself or the original stone from which the prints were taken. The painted hinges here resemble the real ones in the painting *In Memory of My Feelings—Frank O'Hara*, which suggest that the work can be closed upon itself, more than those in the bathroom that it depicts. The whole image, like so many of the recent works, is similar to the painting of John Frederick Peto (1854–1907), the American master whom Johns has admired for many years. *Ventriloquist*, for all its apparent openness, forces us to internalize our experience of the work, and to take it, like Céline's imaginary travels, in the dark, to the other side of the night.

A friend told Johns how good he thought the new work was, with its concatenation of themes and images and its revealing complexities. Johns replied, "It does not feel like that from here. I feel that it should get easier; instead it gets more difficult."

57

111. *Racing Thoughts*, 1983
Encaustic and collage on canvas,
48⅛ x 75⅛ in.
Whitney Museum of American Art, New York
Purchase, with funds from Leo Castelli,
Equitable Life Assurance Society of
the United States, Sidney Kahn, the
Lauder Foundation, and the Painting and
Sculpture Committee

112. *Untitled*, 1983–84
Ink on plastic, 28⅜ x 36¼ in.
Collection of the artist

NOTES

1. Donald Kuspit, "Personal Signs: Jasper Johns," p. 111.

2. Christian Geelhaar, *Jasper Johns: Working Proofs*, p. 39.

3. Michael Crichton, *Jasper Johns*, p. 43.

4. Leo Steinberg, "Jasper Johns," p. 109.

5. Peter Fuller, "Jasper Johns Interviewed I," p. 7.

6. Ibid., p. 8.

7. John Cage, "Jasper Johns: Stories and Ideas," in *A Year from Monday*, p. 78.

8. Fuller, "Jasper Johns Interviewed II," p. 7.

9. Interview with the author, November 1982.

10. Walter Hopps, "An Interview with Jasper Johns," p. 33.

11. Steinberg, "Johns," in *Other Criteria*, p. 31.

12. David Sylvester, interview in *Jasper Johns Drawings*, p. 7.

13. Jasper Johns, "Sketchbook Notes," *Art and Literature*, pp. 185–92.

14. Sylvester, *Johns Drawings*, p. 7.

15. Steinberg, "Johns," in *Other Criteria*, p. 32.

16. Crichton, *Johns*, p. 30.

17. Steinberg, "Johns," in *Other Criteria*, p. 32.

18. Sylvester, *Johns Drawings*, p. 8.

19. Joseph E. Young, "Jasper Johns: An Appraisal," p. 51.

20. Hopps, "Interview," p. 54.

21. Ibid., p. 54.

22. Crichton, *Johns*, p. 30.

23. Reprinted in full in Geelhaar, *Working Proofs*, pp. 33–34.

24. The other artists were J. De Feo, Wally Hedrick, James Jarvaise, Ellsworth Kelly, Alfred Leslie, Landès Lewitin, Richard Lytle, Robert Mallary, Louise Nevelson, Robert Rauschenberg, Julius Schmidt, Richard Stankiewicz, Frank Stella, Albert Urban, and Jack Youngerman.

25. Fuller, "Jasper Johns Interviewed I," p. 6.

26. Fuller, "Jasper Johns Interviewed II, p. 5.

27. Steinberg, "Johns," in *Other Criteria*, p. 53.

28. Cage, "Stories and Ideas," pp. 73–74.

29. Geelhaar, *Working Proofs*, p. 39.

30. Johns, "Sketchbook Notes," p. 84.

31. Ibid.

32. Sigmund Freud, "Resistance and Repression," in *Introductory Lectures on Psychoanalysis* (Harmondsworth, 1973), pp. 336–37.

33. The film *Painters Painting* appeared in 1972; the book *Painters Painting* (Abbeville Press, 1984) is based on the interviews made for the film. See pp. 87–102 and passim.

34. Sylvester, *Johns Drawings*, p. 19.

35. Jasper Johns, statement in *Sixteen Americans*, pp. 22–23.

36. Geelhaar, *Working Proofs*, p. 42.

37. Ibid., p. 39.

38. Crichton, *Johns*, p. 55.

39. Ibid., p. 59.

40. See Jacques Lacan, "The Mirror Stage as Formation of the Function of the I," in *Ecrits* (London, 1980), pp. 1–7.

41. Quoted in Pierre Daix, *Picasso: The Cubist Years* (New York, 1978), p. 28.

42. Quoted in Fuller, "Jasper Johns Interviewed I," p. 5.

43. Interview with the author, November 1982. A fuller description of *Dancers on a Plane* will be published in the Tate Gallery's Biennial Report, 1980–82.

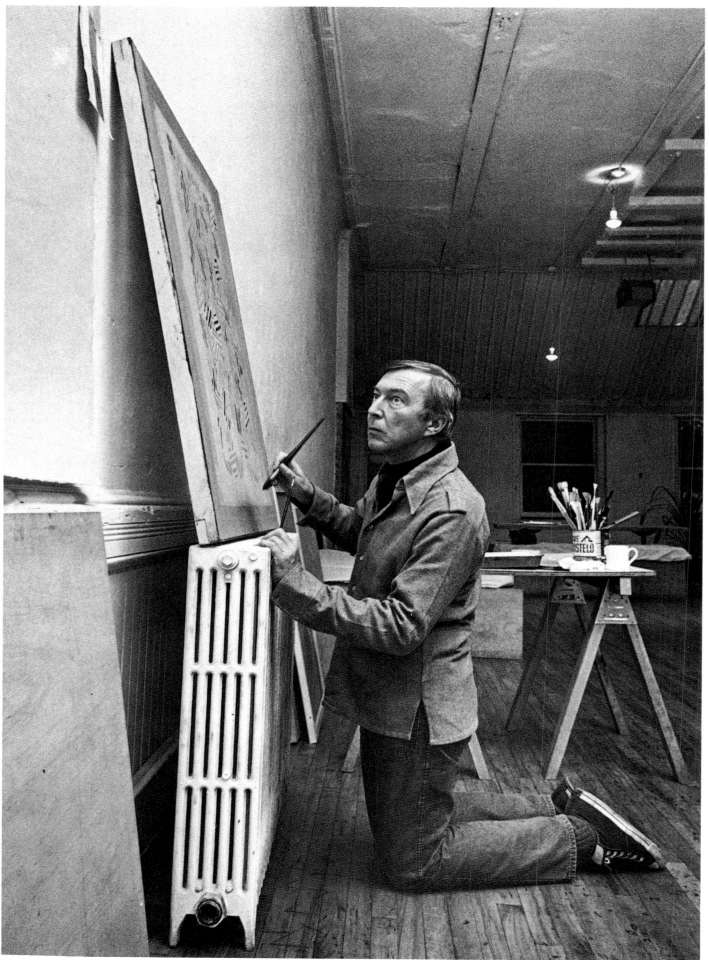

Artist's Statements

Johns's more familiar statements have already been reprinted and are noted in the bibliography. Here we give three that are more difficult to find.

Sometimes I see it and then paint it. Other times I paint it and then see it. Both are impure situations, and I prefer neither.

At every point in nature there is something to see. My work contains similar possibilities for the changing focus of the eye. . . .

Generally, I am opposed to painting which is concerned with conceptions of simplicity. Everything looks very busy to me.

From *Sixteen Americans*, 1959, pp. 22–27.

Sketchbook Notes

one word
two words
(again)

the possibility

of fineness
of broadness
what emerges, in the one case
 " disappears " " other "

2 kinds of "space"
one on top of the other
and/or
one "inside" the other (Is one a detail of the other?)
 " around " "
What can one do with "one includes the other"?
"something" can be either one thing or another
(without turning the rabbit on its side)

We say one thing is not another thing.
Or sometimes we say it is.
Or we say "they are the same".

113. Jasper Johns at Simca Print Artists,
New York, 1976
Photograph by Hans Namuth

In Memory of My Feelings

a resist (transfer?) from wet flatware
and over that
black or dark wash

the mouth (?) and the teeth (?) as in Anita's letter
(There is the possibility of oil as a resist.)
(oil or Vaseline on the teeth to prevent erosion near the gums.)

try to use together
the wall
the layers
the imprint

ways of putting things together
skin and air together

The act of taking food.
The act of preparing and taking food,
The act of hunting.
Water.

whenever they mention culture, I reach for my Brownie

Have made a silk-screen of Baudelaire's description of
sculpture as an inferior art. Use this in VOICE (2) or
somewhere else. Perhaps fragment it so that its legibility
is interfered with.

Shake (shift) parts of some of the letters in VOICE (2).
A not complete unit or a new unit. The elements in the
3 parts should neither fit nor not fit together. One
would like not to be led. Avoid the idea of a puzzle
which could be solved. Remove the signs of "thought".
It is not the "thought" which needs showing.

the application of the eye
the business of the eye

The condition of a presence.
The condition of being here.

its own work
its own
its
it
its shape, color, weight, etc.
it is not another (?)
and shape is not color (?)

Aspects and movable aspects.
To what degree movable?

Entities
splitting.

the idea of background
(and background music) Satie's "Furniture Music" now
idea of neutrality serving as background for music
air and the idea of air as well as background for conver-
(In breathing—in and out) sation. Puns on intentions.

the body as a tube
moisture—such as sweat
rain
re–processing
renaming

From *Juillard*, 1968–69, pp. 25–27. Reprinted courtesy Trevor Winkfield.

Sketchbook Notes

one multiple moving "out"
another " " "in"

(in the same time)

A dotted roller?
A lined roller?

Emboss

High School Days
0 Through 9
Hanging light
The Critic Smiles
Flag
Slice of bread?
A through Z
Paper bag with Duchamp's signature (get photo from Bob Benson)
Ale Cans
Thermometer
Relief Target (Frank Stella)

Color Sequence—Ten Figures—Possible Overprinting

RYB	—	0	—	OVG
VRY	—	1	—	RYB
BVR	—	2	—	VRY
GBV	—	3	—	BVR
YGB	—	4	—	GBV
OYG	—	5	—	YGB
ROY	—	6	—	OYG
VRO	—	7	—	ROY
GVR	—	8	—	VRO
OGV	—	9	—	GVR

Use a squeegee as a diameter or radius (a radius) pivoting to give circular color formations (through a screen). Will there be a straight line at beginning/end? Yes. Silk screens to apply areas of different values. Pos. & neg. dots.

Flagstone ptg. 2 panels. one in oil.
 " " encaustic.

An imagined unit the square of the height of these canvases.

The flagstones enclosed by a border (within this imagined square). The left rectangle (oil?) will include area A.B.C.D. The right (encaustic?) will include E.F.G.H. The meeting B.D. and E.G. will not have borders. (Or will they? Aim for maximum difficulty in determining what has happened?) (The possibility of these—or others—in gray.)

Whether to see the 2 parts as one thing or as two things.

Another possibility: to see that something has happened. Is this best shown by "pointing to" it or by "hiding" it.

Color A over color B. We got that a long time ago. There it is.

It is what it does. What can you do with it? Alternatives. Not a logical system. That is, not contained. continuity/discontinuity

Claes exaggerates. (And not "in order to make a point.")

The colors (?). The thickness of paint. The canvas. (The paint on the canvas.) The kind of paint. The time. The drying time. (As though thought were rapid.) (The objects do not whirl or float in space?) Coming and going but no task. A social drying time.

The dots can be "gathered together" into a line or a mass. (Stewed tomatoes.)

The limited use of whatever ingredient in cooking.

A string with several ends.

Sensibel pensel
Sensible pencil

From *o to 9*, 1969, pp. 1, 2.

114. Jasper Johns in South Carolina, 1965
Photograph by Ugo Mulas

114

Notes on Technique

Johns does not usually make full-scale drawings or full studies before he begins a painting or sculpture. Instead, he keeps a notebook or sketchbook in which his ideas are drawn or written. He has allowed few of these notes to be published, and they relate very closely to particular paintings. They do not describe how to make the works, rather ideas and the results of those thoughts. Johns talks often of impurities—in his technique these consist of the amalgam of material, idea, and image. His technique is important, but it is subservient to the concepts in his work.

Encaustic painting uses wax, normally beeswax, which is sold as flat yellow discs. It melts at 65 degrees C, is soft and pliable when warm, and dissolves easily in turpentine. Johns used encaustic in his early Flag paintings; he recalls (in *Painters Painting*) how he bought canvas and enamel paints to make the Flag image but quickly became frustrated because of the slow drying properties of the paint. He remembered hearing about wax and discovered how to use it; its principal virtue at this time was that it hardened quickly so he could move on to the next part.

In the earliest Flags Johns collaged elements with thread as well as the wax itself; later the wax surface became important to him and was beautifully wrought. The wax dries like a dripping candle; what would be splashes in oil are rounded drips. And the warm surface accepts marks and impressions from objects pushed into it: Johns often builds up the surface and pushes something against it.

Encaustic is brittle; it responds quickly to changes in temperature and is dangerously fragile when cold. It is also remarkably easy to repair: I have seen Johns anneal two surfaces together with an instrument similar to a soldering iron. This also means that it is possible throughout the painting process to excise elements from the picture's surface by applying something hot to it. The iron, for example, is found in many encaustic works. It can be used to attach pieces of collage to the background or to remove areas of the image to allow him to overpaint.

Johns works principally from an ordinary domestic trolley, which he moves back and forth in front of the painting. The colors are heated in small pots (sometimes galvanized tins like Savarin cans)

on a single-ring electric heater, the sort that restaurants use to keep soup warm. Johns told me that the colors come from the tube.

I simply use oil paints—you can use pigments but I use oil paint since the wax medium has it anyway. I make a mixture of beeswax, Dammar (a gum—it can be a varnish) and linseed oil and color. I usually have separate pots of what I'm working with. It dries very quickly, almost instantly.

Q: Does that regulate the stroke?

To a certain extent it does but you can regulate it—it's very easy to control it.[1]

Johns also makes casts out of wax and, especially in the recent work, they are given an extraordinary poignancy by being made of the same materials as the painting.

Johns has also used oil paint throughout his career. Besides being the pigment in his encaustic works, it is the main vehicle for much of the expressive brushwork of the paintings made in the early 1960s. Oil smudges easily; it pulls away if you press something against it. The surface is more fluid than in encaustic painting and the painting itself is constantly changing.

43 John Cage described Johns at work on a Map painting (in oil):

115

He had found a printed map of the United States that represented only the boundaries between them. . . . Over this he had ruled a geometry which he copied enlarged on a canvas. This done, freehand he copied the printed map, carefully preserving its proportions. Then with a change of tempo he began painting quickly, all at once as it were, here and there with the same brush, changing brushes and colors, and working everywhere at the same time rather than starting at one point, finishing it and going on to another. It seemed that he was going over the whole canvas accomplishing nothing, and, having done that, going over it again, and again completely. And so on and on. Every now and then using stencils he put in the name of a state or the abbreviation for it, but having done this represented in no sense an achievement, for as he continued working he often had to do again what he had already done. Something had happened which is to say something had not happened. And this necessitated the repetitions, Colorado, Colorado, Colorado, which were not the same being different colors in different places. I asked how many processes he was involved in. He concentrated to reply and speaking sincerely said: It is all one process.[2]

Johns has been an innovative printmaker; his collaborations with Tatyana Grosman, Ken Tyler, Aldo Crommelynck, Hiroshi Kawanishi, and others have been documented by Richard Field and Christian Geelhaar. Reading their precise descriptions of the processes of making a print and watching Michael Blackwood's film *Decoy* are the easiest ways to appreciate the consummate skill with which Johns handles the techniques of printmaking. He uses conventional techniques, but he does so as a sort of relaxation. He described his approach to Joseph Young in 1969:

The paintings and the prints are two different situations. . . . Primarily, it's the printmaking techniques that interest me. My impulse to make prints has nothing to do with my thinking it's a good way to express

myself. It's more a means to experiment in the technique. What interests me is the technical innovation possible for me in printmaking.

I think partly, I find printmaking an unsatisfactory medium. I keep working at it, trying to make it better. It encourages ideas because of the lapse of time involved, and one wants to use those ideas. The medium itself suggests things changed or left out. Whatever you think the medium is you find out it isn't so you try to test it some other way. I don't really enjoy the idea that it's a reproductive process. A lot of time is taken to make printmaking reproductive, and that's not very interesting to me. In terms of making things, you do something. Then you have to wait for processing. Then you do something else. And then you wait—like a long-distance call through an overseas operator.[3]

1. Interview with the author, November 1982.
2. John Cage, "Jasper Johns: Stories and Ideas," in *A Year from Monday*, p. 75.
3. Joseph E. Young, "Jasper Johns: An Appraisal," p. 51.

116

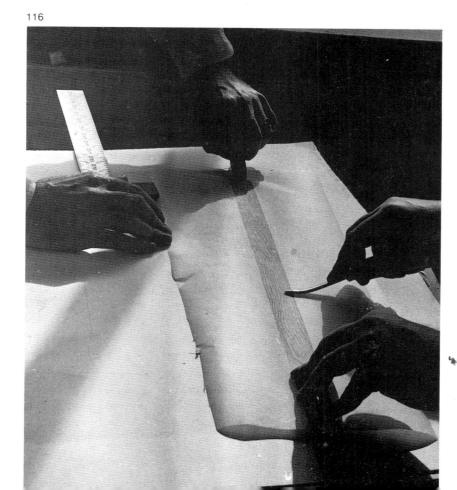

115. Jasper Johns at Gemini G.E.L., Los Angeles, 1978
Photograph by Sidney B. Felsen

116. Jasper Johns at Universal Limited Art Editions, West Islip, New York

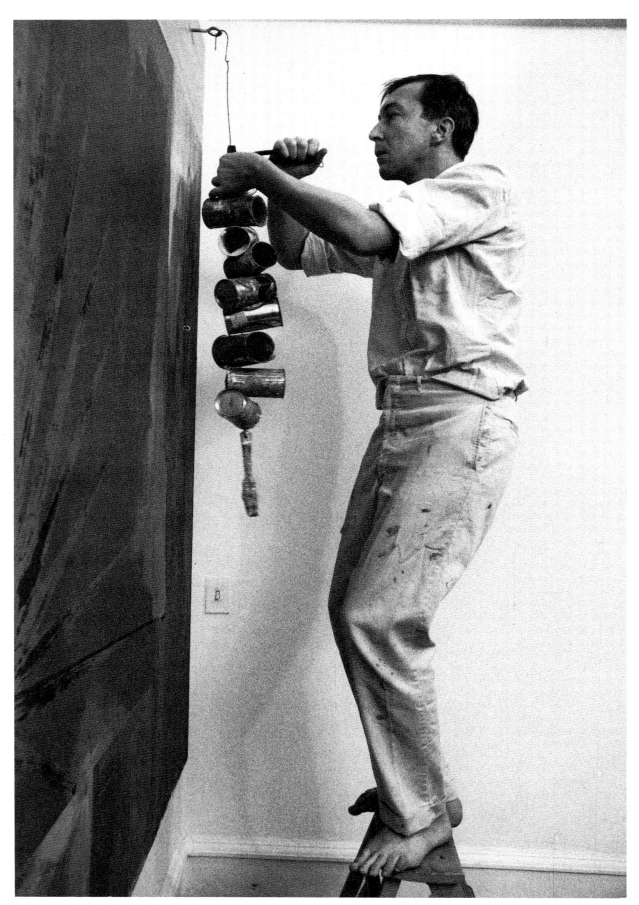

117. Jasper Johns in South Carolina, 1965
Photograph by Ugo Mulas

Chronology By Anna Brooke

1930–46 May 15, 1930—Jasper Johns, Jr., born in Augusta, Georgia, to Jasper Johns and Jean Riley Johns. Spends childhood in Allendale, South Carolina, mainly with his grandparents, aunt, and uncle after his parents separate. After the third grade goes to Columbia, South Carolina, to live with his mother. In fourth grade goes to a small community, called The Corner, South Carolina, for six years to live with an aunt who teaches in a one-room school. Finishes high school in Sumter, South Carolina, living with his mother, stepfather, two half-sisters, and a half-brother.

1947–48 Attends University of South Carolina, for three semesters.

1949–51 Attends commercial art school in New York for two semesters. Quits art school after being offered a scholarship based solely on need because they said that his work did not merit one. Works as a messenger boy and a shipping clerk before being drafted for two years of service by the army. Is stationed at Fort Jackson, South Carolina, and at Sendai, Japan, for six months.

1952 Returns to New York. Enrolls in Hunter College, the Bronx, New York, on the G.I. bill. Quits after one day of classes. Works at Marboro bookstore.

1954 Winter—Suzi Gablik introduces him to Robert Rauschenberg. At Sari Dienes's apartment meets Rauschenberg again, as well as John Cage and Morton Feldman. Spring—quits bookstore. With Rauschenberg does free-lance window display work for Gene Moore for Bonwit Teller and Tiffany. Makes collages and drawings. Moves from East Eighty-third Street to East Eighth Street; later moves to Pearl Street to a loft on the floor below that of a friend, Rachel Rosenthal. Rauschenberg lives nearby, on Fulton Street. Only four pieces survive from this period: *Construction with Toy Piano*, 1954; *Untitled*, 1953; *Untitled*, 1954; and *Star*, 1954. Starts first Flag painting.

1955 January—Rachel Rosenthal moves to California, and Rauschenberg moves into her loft. Paints *White Flag* and first Target pictures, *Target with Four Faces*, *Target with Plaster Casts*, and first four Number paintings, of figures 1, 2, 5, and 7. With Rauschenberg, attends concert of Cage's music in Rockland County, New York, organized by Emile de Antonio. De Antonio becomes agent for their display business, named Matson Jones.

1956–57 Makes first Alphabet painting, *Gray Alphabets*. Makes paintings with objects, including *Canvas*, 1956; *Book*, 1957; *Drawer*, 1957. March—*Green Target*, 1955, his first painting seen in a museum exhibition, is shown in *Artists of the New York School: Second Generation* at the Jewish Museum. Leo Castelli sees the painting there and later meets Johns while visiting Rauschenberg's studio. May—*Flag*, 1955, is included in group show *New Work* at Castelli Gallery.

1957–58 Gene Moore invites artists who do display work to show their paintings in store windows: *Flag on Orange Field* and *White Flag* are exhibited in Bonwit Teller's windows.

1958 January—first solo show in New York held at Leo Castelli Gallery; includes Flags, Targets, and Numbers. From this time shows regularly at Castelli (1960, 1961, 1963, 1966, 1968, 1970, 1976, 1981, 1984). *Target with Four Faces* is on the cover of *Artnews* and is purchased by Alfred Barr with two other of his paintings for the Museum of Modern Art. Makes first sculptures, including *Lightbulb I* and *Flashlight*. Paintings include *Three Flags* and *Tennyson*. May—with Rauschenberg and de Antonio organizes Cage retrospective concert at Town Hall, New York City. June–October—three of his paintings are included in the *XXIX Venice Biennale*, with work by Joan Mitchell and Richard Stankiewicz. December–February 1959—*Gray Numbers*, 1958, included in *Pittsburgh Biennial International Exhibition of Contemporary Painting and Sculpture*,

Carnegie Institute; wins International Prize. First reads about Marcel Duchamp in Robert Motherwell's anthology, *Dada Painters and Poets*, and sees Duchamp's work in the Philadelphia Museum of Art about this time.

1959 Reads Robert Lebel's book on Marcel Duchamp. Nicolas Calas brings Duchamp to Johns's studio on Front Street. Johns uses stencils of color names in paintings such as *False Start* and *Jubilee*. March—first foreign solo exhibition held at Galleria d'Arte del Naviglio, Milan. October—he and Rauschenberg paint opposite sides of a piece of fabric in Allan Kaprow's *Eighteen Happenings in Six Parts* at Rubin Gallery, New York. December—nine of his paintings are included in *Sixteen Americans*, Museum of Modern Art, organized by Dorothy Miller.

1960 Makes two sculptures called *Painted Bronze*: Ballantine ale cans and paint brushes in a Savarin coffee can. Makes *Painting with Two Balls*. Commissioned by Mr. and Mrs. Robert C. Scull of New York to paint a large single number, *Figure 5*. August—makes first lithograph at the invitation of Tatyana Grosman, founder of Universal Limited Art Editions, who brings two lithographic stones to Front Street. Makes lithograph, *Target*, followed by *0 through 9*. December—in *Scrap* magazine reviews *The Bride Stripped Bare by Her Bachelors, Even*, a typographic version by Richard Hamilton of Marcel Duchamp's *Green Box*, translated by George Heard Hamilton.

1961 Makes first large Map painting. Reads available English translations of work by philosopher Ludwig Wittgenstein, including *Philosophical Remarks, Notebooks, Philosophical Investigations*. Buys house at Edisto Beach, South Carolina. June—first visits Paris for exhibition of his work at Galerie Rive Droite. June 20—contributes to David Tudor's performance of "Variation II" by Cage at American Embassy Theater in Paris, with Rauschenberg, Tinguely, Niki de Saint Phalle; Johns's painting *Entr'Acte*

is shown at intermission. Designs costumes for Merce Cunningham's "Suite de Danses." Paintings include *No, Good Time Charley, By the Sea.*

1962 Makes paintings *4 the News* and *Fool's House,* as well as *Study for Skin* drawings.

1963 Rents penthouse on Riverside Drive; lives and works there and in South Carolina. Is a founding director of the Foundation for Contemporary Performance Arts, Inc. Makes painting and drawing *Diver* and the painting *Periscope (Hart Crane).* Starts a collaboration with Frank O'Hara and completes one lithograph, *Skin with O'Hara Poem.*

1964 February–April—first major solo retrospective exhibition held at the Jewish Museum, with catalog essays by Cage and Alan Solomon. Spring—spends month on Oahu, Hawaii, with Cage and Lois Long, followed by second visit to Japan, where he paints *Watchman.* At U.L.A.E makes lithograph *Ale Cans.* A film on Johns is made for South Carolina educational television. Summer—is included in *XXXII Venice Biennale,* organized by Alan Solomon. Makes *According to What.* December—attends opening in London of retrospective exhibition held at Whitechapel Gallery, organized by Bryan Robertson.

1965 January—travels to Pasadena for opening of retrospective exhibition at Pasadena Art Museum, organized by Walter Hopps. Sees Duchamp exhibition at Cordier Ekstrom Gallery, *Not Seen and/or Less Seen of/by Marcel Duchamp/Rrose Selavy 1904–1964.* June—wins prize at *VI International Exhibition of Graphic Art,* Ljubljana, Yugoslavia. Paintings made in South Carolina include *Eddingsville,* large *Untitled* (1964–65), *Flags* with flag in complementary colors.

1966 Makes painting *Passage II* and lithographs *Passage I and II.* David Whitney becomes his assistant (until 1968). October–November—solo exhibition of drawings held at National Collection of Fine Arts, Washington, D.C. During his third visit to Japan, a fire destroys his house and studio at Edisto Beach.

1967 Leaves Riverside Drive; lives in Chelsea Hotel temporarily. Rents a loft on Canal Street where he paints *Harlem Light,* introducing the flagstone motif, and *Screen Piece.* Buys building, formerly a bank, on the Lower East Side in Manhattan. Makes illustration for *In Memory of My Feelings,* a memorial book of Frank O'Hara's poems published by the Museum of Modern Art. Becomes artistic advisor to Merce Cunningham Dance Company and invites collaborations from other artists, including Robert Morris, Frank Stella, Andy Warhol, and Bruce Nauman (until 1972). Makes first etchings at U.L.A.E. June—wins prize at *VII International Exhibition of Graphic Art,* Ljubljana. September—three works included in *IX Bienal de São Paulo;* one of ten winners of the "Premio Bienal de São Paulo." Makes *Map,* based on

Buckminster Fuller's Dymaxion Airocean Projection of the World, for the U.S. pavilion at the 1967 Montreal World's Fair.

1968 March 10—premiere performance held in Buffalo of Cunningham's "Walkaround Time," with sets based on Duchamp's *The Large Glass* and costumes designed by Johns. March –April—spends seven weeks at Gemini G.E.L. lithography workshop in Los Angeles. Makes series of ten black and gray *Numerals* and one large *Gray Alphabet,* printed March–May by Kenneth Tyler. Major monograph by Max Kozloff published.

1968–1969 August–May—works on *Lead Reliefs* and *No* lithograph at Gemini. Makes Alphabet lithograph, *A through Z,* and *0 through 9* Numerals. Makes screenprint, *Target with Four Faces,* from which a poster is made for the Cunningham Dance Company.

1969 Works in Los Angeles at Gemini. *Figures in Color* lithograph is published. December— makes poster for the Vietnam Moratorium Committee.

1970 April–June—major retrospective of prints, 1960–70, held at Philadelphia Museum of Art, organized by Richard Field. Poster is made from *Souvenir* lithograph. December— major retrospective of prints opens at Museum of Modern Art, New York, organized by Riva Castleman. Designs costumes for Cunningham's "Second Hand."

1971 Makes *Decoy* lithograph followed by *Decoy* painting; Blackwood Productions makes *Jasper Johns Decoy,* a film narrated by Barbara Rose. Gemini publishes *Fragments—According to What,* a set of six lithographs. Finishes repainting *Map* from 1967. December 3— "Loops" is performed by Cunningham at the Museum of Modern Art in front of Jasper Johns's *Map.*

1972 Paints *Untitled,* a four-panel painting; first use of crosshatching pattern. First makes screenprints with Hiroshi Kawanishi of Simca Print Artists. April—receives Skowhegan Medal for painting. Designs costumes for Merce Cunningham's "T.V. Rerun" and "Landrover."

1973 Vera Lindsay initiates collaboration between Johns and Samuel Beckett, who meet in Paris while Johns is working on designs for Cunningham's ballet "Un Jour ou deux," performed at the Paris Opéra. February—elected member of National Institute of Arts and Letters, New York. October—in the auction of works from the Scull collection at Parke Bernet *Double White Map* sells for $240,000, setting a record for work by a living American artist. Moves to upstate New York.

1974 Paints *Scent,* 1973–74, and *Corpse and Mirror.* Mark Lancaster becomes his assistant.

1975 March—returns to Gemini to work on gray and black version of *Four Panels from Untitled.* Works in Paris at Atelier Crommelynck on etchings for the book *Foirades/Fizzles.* Paints *The Dutch Wives* and *Weeping Women.*

1976 *Foirades/Fizzles,* with thirty-three etchings by Johns and five texts by Samuel Beckett, is published by Petersburg Press in a limited edition of 250. Gemini publishes a series of six lithographs based on the painting *Untitled,* 1975.

1977 April—receives Skowhegan Medal for graphics. October—major retrospective of over 200 paintings, sculptures, and works on paper organized by David Whitney with a catalog by Michael Crichton opens at Whitney Museum of American Art. Exhibition travels to Europe and Japan; Johns attends openings. Makes first monotypes. Paints *Usuyuki.*

1978 March—major exhibition of prints, 1970–77, organized by Richard Field, opens at Center for the Arts, Wesleyan University, with national tour. Makes sets and costumes for Merce Cunningham's "Exchange." Katrina Martin makes 16mm. film *Hanafuda,* which shows the printing of Johns's screenprints, including *The Dutch Wives* (published by Simca Print Artists). Two paintings are included in *XXXX Venice Biennale.* Paints *Céline.*

1979 April—major solo print exhibition organized by Christian Geelhaar, *Jasper Johns: Working Proofs,* opens at Kunstmuseum Basel, with European tour. Paints first version of *Dancers on a Plane* and begins second version (finished 1980).

1980 September—Whitney Museum pays one million dollars for *Three Flags.*

1981 January—exhibition of ten years of drawings held at Leo Castelli. Paints *Between the Clock and the Bed.*

1982 Makes series of seventeen Savarin monotypes at U.L.A.E. Paints *In the Studio, Perilous Night.*

1983 Paints *Racing Thoughts.* Makes a series of lithographs based on *Voice 2* at U.L.A.E.

118. Exhibition of drawings at Leo Castelli Gallery, 1981

Exhibitions

Solo Exhibitions

1958

Jasper Johns Painting, Leo Castelli Gallery, New York, January 20–February 8.

1959

Jasper Johns, Galerie Rive Droite, Paris, January 16–March.

Jasper Johns, Galleria d'Arte del Naviglio, Milan, March 21–30.

1960

Jasper Johns, Leo Castelli Gallery, February 15–March 5.

Paintings by Jasper Johns, University Gallery, University of Minnesota, Minneapolis, May 3–June 15.

Jasper Johns 1955–1960, Columbia Museum of Art, Columbia, South Carolina, December 7–29.

1961

Jasper Johns: Drawings and Sculpture, Leo Castelli Gallery, January 31–February 25.

Jasper Johns: Peintures et sculptures et dessins et lithos, Galerie Rive Droite, June 13–July 12.

1962

Jasper Johns Retrospective Exhibition, Everett Ellin Gallery, Los Angeles, November 19–December 15.

1963

Jasper Johns, Leo Castelli Gallery, January 12–February 7.

1964

Jasper Johns, Jewish Museum, New York, February 16–April 12.

Jasper Johns: Paintings, Drawings, and Sculpture, 1954–1964, Whitechapel Gallery, London, December.

1965

Jasper Johns Retrospective, Pasadena Art Museum, Pasadena, California, January 26–February 28.

1966

Jasper Johns, Leo Castelli Gallery, March.

The Drawings of Jasper Johns, National Collection of Fine Arts, Washington, D.C., October 6–November 13.

1968

Jasper Johns, Leo Castelli Gallery, April.

Jasper Johns: Lithographs, Documenta 4, Kassel, Germany, June 17–October 6, and Museum of Modern Art tour to Louisiana Museum, Humlebaek, Denmark; Kunstmuseum Basel; Moderna Galerija, Ljubljana, Yugoslavia; Museum of Modern Art, Belgrade, Yugoslavia; National Gallery of Prague; Museum Sztuki w Lodzi, Lodz, Poland; Romanian Athenaeum, Bucharest.

1969

Jasper Johns: Lead Reliefs, Leo Castelli Gallery, May 10–29.

Jasper Johns: The Graphic Work, Marion Koogler McNay Art Institute, San Antonio, July 6–August 6, and tour to Pollock Galleries, Southern Methodist University, Dallas; University Art Museum, University of New Mexico, Las Cruces; Des Moines Art Center, Des Moines, Iowa.

1970

Jasper Johns: Drawings, Leo Castelli Gallery, January 10–31.

Jasper Johns: Drawings and Graphics, Irving Blum Gallery, Los Angeles, April.

Jasper Johns: Prints 1960–1970, Philadelphia Museum of Art, April 15–June 14.

Jasper Johns, Heath Gallery, Atlanta, June 17–30.

Jasper Johns: Lithographs, Museum of Modern Art, New York, December 22–May 3, and tour to Albright-Knox Art Gallery, Buffalo, New York; Tyler Museum of Art, Tyler, Texas; San Francisco Museum of Modern Art; Baltimore Museum of Art; Virginia Museum of Fine Arts, Richmond; Museum of Fine Arts, Houston.

1971

Jasper Johns: "Map," Minneapolis Institute of Arts, March, and tour to Marion Koogler McNay Art Institute; Museum of Modern Art.

Jasper Johns, Dayton's Gallery 12, Minneapolis, March 10–31.

Jasper Johns: 1st Etchings, 2nd State, Betty Gold Fine Modern Prints, Los Angeles, March 23–April 23.

Jasper Johns Graphik, Kunsthalle, Bern, April 17–May 29, and tour to Hannover Kunstverein; Stedelijk Museum, Amsterdam; Städtisches Museum, Mönchengladbach; Castello Sforzesco, Milan.

1972

Jasper Johns "Decoy": The Print and the Painting, Emily Lowe Gallery, Hofstra University, Hempstead, Long Island, September 14–October 15.

1974

New Series of Lithographs by Jasper Johns, Gemini G.E.L., Los Angeles, March.

Jasper Johns: Selected Graphics, Christ Janer Gallery, New Canaan, Connecticut, April 5–May.

Jasper Johns: Drawings, Oxford Museum of Modern Art, September 7–October 13, and Arts Council of Great Britain tour to Mappin Art Gallery, Sheffield; Herbert Art Gallery, Coventry; Walker Art Gallery, Liverpool; City Art Gallery, Leeds; Serpentine Gallery, London.

Jasper Johns, Leo Castelli Gallery, October.

Jasper Johns: Drawings, Minami Gallery, Tokyo, October 27–November 15.

Jasper Johns: 1st Etchings, 1st State and 1st Etchings, 2nd State, Knoedler Contemporary Prints, New York, November.

1976

Jasper Johns, Leo Castelli Gallery, January 24–February 14.

Jasper Johns: Matrix 20, Wadsworth Atheneum, Hartford, May 15–July 1.

Jasper Johns: Six New Color Lithographs, Gemini G.E.L., December.

1977

Jasper Johns: Graphic Work, Blum Helman, New York, October.

Foirades/Fizzles, Whitney Museum of American Art, New York, October 11–November 20.

Jasper Johns, Whitney Museum of American Art, October 18–January 22, 1978, and tour to Museum Ludwig, Cologne; Centre National d'Art et de Culture Georges Pompidou, Musée National d'Art Moderne, Paris; Hayward Gallery, London; Seibu Museum of Art, Tokyo; San Francisco Museum of Modern Art.

Jasper Johns: Drawings and Prints, John Berggruen Gallery, San Francisco, October 20–November 25.

Jasper Johns: Prints, Getler/Pall, New York, October 22–November 19.

Jasper Johns: A Retrospective Exhibition of Prints 1960–1976, University of California, Mary Porter Sesnon Art Gallery, Santa Cruz, California, November 2–December 10.

Jasper Johns: Screenprints, Brooke Alexander, New York, November 15–January 7, 1978.

1978

Jasper Johns: 1st Etchings, Museum of Fine Arts, Boston, January 14–March 12.

Jasper Johns: After Untitled 1974–1977: The Development of Two Graphic Images, Margo Leavin Gallery, Los Angeles, March 18–April 29.

Jasper Johns: Prints, 1970–1977, Center for the Arts, Wesleyan University, Middletown, Connecticut, March 27–April 25, and tour to Springfield Museum of Art, Springfield, Massachusetts; Baltimore Museum of Art; Hopkins Center, Dartmouth College Museum and Galleries, Hanover, New Hampshire; University Art Museum, University of California, Berkeley; Cincinnati Art Museum; Georgia Museum of Art, University of Georgia, Athens; Saint Louis Art Museum, Saint Louis, Missouri; Newport Harbor Art Museum, Newport Beach, California; Museum of Art, Rhode Island School of Design, Providence, Rhode Island.

Jasper Johns: Screenprints, Galerie Mukai, Tokyo, August 21–September 9.

Jasper Johns: Prints and Drawings, John Berggruen Gallery, San Francisco, October 20–November 25.

Jasper Johns: Screenprints, Akron Art Museum, Akron, Ohio, December 8–January 21, 1979, and tour to Seattle Art Museum; Centre for the Arts, Simon Fraser Gallery, Simon Fraser University, Burnaby, British Columbia; Phoenix Art Museum; Portland Art Museum; San Jose Museum of Art, San Jose, California; Tucson Museum of Art, Tucson, Arizona; Roswell Museum and Art Center, Roswell, New Mexico; University Art Gallery, University of Texas at Arlington; Arkansas Arts Center, Little Rock, Arkansas; Tyler Museum of Art, Tyler, Texas; Center for the Visual Arts Gallery, Illinois State University, Normal, Illinois; Toledo Museum of

Art; J. B. Speed Art Museum, Louisville, Kentucky; Springfield Art Museum, Springfield, Massachusetts.

1979

Jasper Johns: Working Proofs, Kunstmuseum Basel, April 7–June 2, and tour to Staatliche Graphische Sammlung, Munich; Städelsches Kunstinstitut und Städtische Galerie, Frankfurt; Kunstmuseum Hannover mit Sammlung Sprengel; Konigliche Kupferstichsammlung, Statens Museum for Kunst, Copenhagen; Moderna Museet, Stockholm; Tate Gallery, London.

Jasper Johns: Drawings and Prints 1975–1979, Janie C. Lee Gallery, Houston, April 21–May 28.

Jasper Johns: Graphics, Little Center Gallery, Clark University, Worcester, Massachusetts, September 24–October.

Jasper Johns: Lithographs, Getler/Pall, November 6–December 15.

1980

Jasper Johns: "Color Numeral Series, 1969," Getler/Pall Gallery and Patricia Heesy Fine Art, New York, December 30–January 24, 1981.

1981

Jasper Johns: Drawings, Leo Castelli Gallery, January.

Jasper Johns: Drawings 1970–1980, Margo Leavin Gallery, February 21–March 28.

Recent Prints: Jasper Johns, Greenberg Gallery, Saint Louis, Missouri, March–April.

Jasper Johns: Prints 1977–1981, Thomas Segal Gallery, Boston, October 24–December 2.

1982

Two Themes: Usuyuki and Cicada, Castelli Graphics, New York, January 9–30.

Jasper Johns, L. A. Louver Gallery, Venice, California, February 16–March 13.

Jasper Johns: Savarin Monotypes, Whitney Museum of American Art, November 10–January 9, 1983.

1983

Jasper Johns: Prints, Delahunty Gallery, Dallas, November 12–December 14.

1984

Jasper Johns Paintings, Leo Castelli Gallery, January 28–February 27.

Group Exhibitions

1957

Artists of the New York School: Second Generation, Jewish Museum, New York, March 10–April 28.

New Work: Bluhm, Budd, Dzubas, J. Johns, Leslie, Louis, Marisol, Ortman, Rauschenberg, Savelli, Leo Castelli Gallery, New York, May 6–25.

Collage in America, Zabriskie Gallery, New York, December 16–January 4, 1958, and American Federation of Arts tour.

1958

Collage International: From Picasso to the Present, Contemporary Arts Museum, Houston, February 27–April 6.

XXIX Biennale di Venezia, Venice, June 14–September 30 (also included in 1964, 1978 exhibitions).

New Generation, Cushing Memorial Gallery, Newport, Rhode Island, July 1–31.

1958 Pittsburgh Biennial International Exhibition of Contemporary Painting and Sculpture, Carnegie Institute, Pittsburgh, December 5–February 8, 1959 (also included in 1961, 1967 exhibitions).

1959

100 Works on Paper: I. United States, Boston Institute of Contemporary Art, and international tour.

1959 Annual Exhibition of Contemporary American Painting, Whitney Museum of American Art, New York, December 9–January 31, 1960 (also included in 1960, 1961, 1963, 1973, 1983 exhibitions).

Exposition Internationale du Surréalisme, Galerie Daniel Cordier, Paris, December 15–February 14, 1960.

Sixteen Americans, Museum of Modern Art, New York, December 16–February 14, 1960.

1960

Contemporary American Painting, Columbus Gallery of Fine Arts, Columbus, Ohio, January 14–February 18.

1961

64th American Exhibition: Paintings, Sculpture, Art Institute of Chicago, January 6–February 5 (also included in 1962, 1976 exhibitions).

The Art of Assemblage, Museum of Modern Art, October 4–November 12, and tour.

American Abstract Expressionists and Imagists, Solomon R. Guggenheim Museum, New York, October 13–December.

1962

4 Amerikanare: Jasper Johns, Alfred Leslie, Robert Rauschenberg, Richard Stankiewicz, Moderna Museet, Stockholm, March 17–May 6, and tour.

American Art since 1950, Fine Arts Pavilion, Seattle World's Fair, April–October, and tour.

1963

Six Painters and the Object, Solomon R. Guggenheim Museum, March 14–June 12.

The Popular Image, Institute of Contemporary Art, London, October 24–November 23.

New Directions in American Painting, Munson-Williams-Proctor Institute, Utica, December 1–January 5, 1964, and tour.

Black and White, Jewish Museum, December 12–February 5, 1964.

1964

Painting and Sculpture of a Decade 54–64, Tate Gallery, London, April–June.

XX Salon de mai, Musée d'Art Moderne de la Ville de Paris, May 16–June 7.

Documenta 3, Museum Fridericianum, Kassel, June 27–October 5 (also included in 1968, 1977 exhibitions).

American Drawings, Solomon R. Guggenheim Museum, September–October.

Premio nacional e internacional, Instituto Torcuato di Tella, Buenos Aires, October–November.

1965

A Decade of American Drawings 1955–1965, Whitney Museum of American Art, April 28–June 6.

Word and Image, Solomon R. Guggenheim Museum, September–October.

1966

The Object Transformed, Museum of Modern Art, June 28–August 21.

The Art of the United States 1670–1966, Whitney Museum of American Art, September 28–November 27.

Art in the Mirror, Museum of Modern Art, November 2–February 5, 1967, and tour.

1967

30th Biennial Exhibition of Contemporary American Painting, Corcoran Gallery of Art, Washington, D.C., February 24–April 19 (also included in 1979 exhibition).

IX Bienal de São Paulo, Museu de Arte Moderna, September 22–January 8, 1968.

1968

Word and Image: Posters from the Collection of the Museum of Modern Art, Museum of Modern Art, January 25–March 10.

Dada, Surrealism, and Their Heritage, Museum of Modern Art, March 27–June 9, and tour.

The Art of the Real U.S.A. 1948–1968, Museum of Modern Art, July 3–September 8, and tour.

1969

Twentieth Century Art from the Nelson A. Rockefeller Collection, Museum of Modern Art, May 28–September 1.

Pop Art, Hayward Gallery, London, July 9–September 3.

New York Painting and Sculpture 1940–1970, Metropolitan Museum of Art, New York, October 18–February 1, 1970.

Painting in New York: 1944–1969, Pasadena Art Museum, Pasadena, California, November 24–January 11, 1970.

Prints by Four New York Painters: Helen Frankenthaler, Jasper Johns, Robert Motherwell, Barnett Newman, Metropolitan Museum of Art, December 15–February 1, 1970.

1971

Technics and Creativity: Gemini G.E.L., Museum of Modern Art, May 5–June 6.

1973

Modern Prints, Art Gallery of Western Australia, Perth, Australia, April 19–May 6, and tour. Organized by the International Council of the Museum of Modern Art.

1974

American Pop Art, Whitney Museum of American Art, April 6–June 16.

Johns, Kelly, Lichtenstein, Motherwell, Nauman, Rauschenberg, Serra, Stella: Prints from Gemini G.E.L., Walker Art Center, Minneapolis, Minnesota, August 17–September 29, and tour.

1976

Drawing Now, Museum of Modern Art, January 23–March 9, and international tour.

Twentieth-Century American Drawings: Three Avant-Garde Generations, Solomon R. Guggenheim Museum, January 23–March 21.

1978

Art about Art, Whitney Museum of American Art, July 19–September 24, and tour.

American Painting of the 1970's, Albright Knox Art Gallery, Buffalo, December 8–January 14, 1979, and tour.

1979

Contemporary American Prints from Universal Limited Art Editions: The Rapp Collection, Art Gallery of Ontario, Toronto, January 20–March 4.

Poets and Painters, Denver Art Museum, November 21–January 13, 1980, and tour.

1980

Printed Art since 1965, Museum of Modern Art, February 13–April 1.

The Fifties: Aspects of Painting in New York, Hirshhorn Museum and Sculpture Garden, Smithsonian Institution, Washington, D.C., May 22–September 21.

Artist and Printer: Six American Print Studios, Walker Art Center, December 7–January 18, 1981.

1981

American Prints: Process and Proofs, Whitney Museum of American Art, November–January 1982.

1982

Surveying the Seventies: Selections from the Permanent Collection of the Whitney Museum of American Art, Whitney Museum of American Art, Fairfield County, Connecticut, February 12–March 31.

The Michael and Dorothy Blankfort Collection, Los Angeles County Museum of Art, April 1–June 13.

'60 '80 Attitudes, Concepts, Images, Stedelijk Museum, Amsterdam, April 9–July 11.

For 25 Years: Prints from U.L.A.E., Museum of Modern Art, June–September.

Block Prints, Whitney Museum of American Art, September 9–November 7.

1983

American Still Life 1945–1983, Contemporary Arts Museum, Houston, September 20–November 20, and tour.

The American Artist as Printmaker, Brooklyn Museum, October 28–January 22, 1984.

Public Collections

Aachen, West Germany, Neue Galerie Ludwig
Amsterdam, The Netherlands, Stedelijk Museum
Basel, Switzerland, Kunstmuseum Basel
Boston, Massachusetts, Museum of Fine Arts
Buffalo, New York, Albright-Knox Art Gallery
Chicago, Illinois, Art Institute of Chicago
Cologne, West Germany, Museum Ludwig
Dallas, Texas, Dallas Museum of Fine Arts
Darmstadt, West Germany, Hessisches Landes-
 museum
Denver, Colorado, Denver Art Museum
Des Moines, Iowa, Des Moines Art Center
Hartford, Connecticut, Wadsworth Atheneum
London, England, Tate Gallery
London, England, Victoria and Albert Museum
Los Angeles, California, Los Angeles County
 Museum of Art
New York City, New York, Metropolitan Mu-
 seum of Art
New York City, New York, Museum of Modern
 Art
New York City, New York, Solomon R. Gug-
 genheim Museum
New York City, New York, Whitney Museum of
 American Art
Oberlin, Ohio, Allen Memorial Art Museum
San Francisco, California, San Francisco Museum
 of Modern Art
Stockholm, Sweden, Moderna Museet
Stockholm, Sweden, Nationalmuseum
Tokyo, Japan, Seibu Museum of Art
Waltham, Massachusetts, Brandeis University
 Art Collection, Rose Art Museum
Washington, D.C., Hirshhorn Museum and
 Sculpture Garden, Smithsonian Institution
Washington, D.C., National Gallery of Art
Washington, D.C., National Museum of Ameri-
 can Art, Smithsonian Institution
Zurich, Switzerland, Kunsthaus Zürich

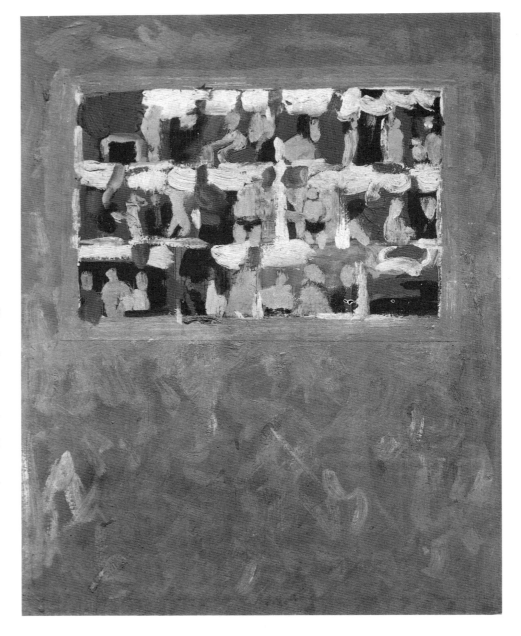

119. *Alley Oop*, 1958
Oil and collage on cardboard, 23⁵⁄₁₆ x 18 in.
Robert Rauschenberg

Selected Bibliography

Interviews and Statements

Bernard, April, and Thompson, Mimi. "Johns On . . ." *Vanity Fair* 47 (February 1984): 65.

Bourdon, David. "Jasper Johns: 'I Never Sensed Myself as Being Static.'" *Village Voice*, October 31, 1977, p. 75. Interview.

Coplans, John. "Fragments According to Johns: An Interview with Jasper Johns." *Print Collector's Newsletter* 3 (May–June 1972): 29–32. Discussions of lithographic series *Fragments According to What* made at Gemini G.E.L. in 1971.

Fuller, Peter. "Jasper Johns Interviewed I." *Art Monthly* 18 (July–August 1978): 6–12. "Part 2." *Art Monthly* 19 (September 1978): 5–7.

Geelhaar, Christian. "Interview with Jasper Johns." In *Jasper Johns: Working Proofs*, exhibition catalog. Basel: Kunstmuseum Basel, 1979, pp. 63–72. Reprinted New York: Petersburg Press, 1980.

Glueck, Grace. "The 20th-Century Artists Most Admired by Other Artists." *Artnews* 76 (November 1977): 78–103. See pp. 87–89. Statement.

Hopps, Walter. "An Interview with Jasper Johns." *Artforum* 3 (March 1965): 32–36.

Johns, Jasper. Statement in *Sixteen Americans*, exhibition catalog. New York: Museum of Modern Art, 1959, pp. 22–27. Reprinted in Barbara Rose, ed., *Readings in American Art since 1900: A Documentary Survey*, New York: Praeger Publishers, 1968, pp. 165–66.

————. "Duchamp." *Scrap* 2 (December 23, 1960): 4.

————. "Sketchbook Notes." *Art and Literature* 4 (Spring 1965): 185–92. Notes on *According to What*. Reprinted in John Russell and Suzi Gablik, *Pop Art Redefined*, New York: Praeger Publishers, 1969, pp. 84–85, and in Barbara Rose, ed., *Readings in American Art 1900–1975*, New York: Praeger Publishers, 1975, pp. 176–78.

————. "Marcel Duchamp (1887–1968): An Appreciation." *Artforum* 7 (November 1968): 6. Reprinted in Pierre Cabanne, *Dialogues with Marcel Duchamp*, New York: Viking Press, 1971, pp. 109–10, and Anne d'Harnoncourt and Kynaston McShine, eds. *Marcel Duchamp*, New York: Museum of Modern Art, 1973, pp. 203–4.

————. "Sketchbook Notes." *Juillard* 3 (Winter 1968–69): 25–27.

————. "Sketchbook Notes." *Art Now: New York* 1 (April 1969): n.p.

————. "Sketchbook Notes." *0 to 9*, no. 6 (July 1969), pp. 1–2.

————. "Thoughts on Duchamp." *Art in America* 57 (July–August 1969): 31.

————, illustrations, and Beckett, Samuel, text. *Pour finir encore et autres foirades*. Paris: Editions de Minuit, 1976. English edition, *Foirades/Fizzles*. London: Petersburg Press, 1976.

Pohlen, Annelie. "Interview mit Jasper Johns." *Heute Kunst* 22 (May–June 1978): 21–22.

Raynor, Vivian. "Jasper Johns: 'I Have Attempted to Develop My Thinking in Such a Way That the Work I've Done Is Not Me.'" *Artnews* 72 (March 1973): 20–22. Interview.

Swenson, G. R. "What Is Pop Art? Part 2." *Artnews* 62 (February 1964): 40–43, 62–67. See p. 43. Reprinted in Russell and Gablik, *Pop Art Redefined*, pp. 82–83. Interview.

Monographs and Solo-Exhibition Catalogs

Bernstein, Roberta. Introduction to *Jasper Johns "Decoy": The Print and the Painting*, exhibition catalog. Hempstead, L.I.: Emily Lowe Gallery, Hofstra University, 1972.

Castleman, Riva. *Jasper Johns: Lithographs*, exhibition catalog. New York: Museum of Modern Art, 1970.

Crichton, Michael. *Jasper Johns*, exhibition catalog. New York: Harry N. Abrams and Whitney Museum of American Art, 1977.

Ellin, Everett. Introduction to *Jasper Johns Retrospective Exhibition*, exhibition catalog. Los Angeles: Everett Ellin Gallery, 1962.

Field, Richard S. Preface to *Jasper Johns: 1st Etchings, 2nd State*, exhibition catalog. Los Angeles: Betty Gold Fine Modern Prints, 1971.

————. *Jasper Johns: Prints 1960–1970*. New York: Praeger Publishers, 1970. Published in association with the Philadelphia Museum of Art. Includes reprint of Jasper Johns's "Watchman" and "Souvenir" from "Sketchbook Notes," 1965.

————. *Jasper Johns: Matrix 20*, exhibition catalog. Hartford: Wadsworth Atheneum, 1976.

————. *Jasper Johns: Screenprints*, exhibition catalog. New York: Brooke Alexander, 1977.

————. *Jasper Johns: Prints, 1970–1977*, exhibition catalog. Middletown, Conn.: Wesleyan University, 1978.

Geelhaar, Christian. *Jasper Johns Arbetsprocessor Grafik 1960–1976*, exhibition catalog. Stockholm: Moderna Museet, 1976. Includes an interview by Christian Geelhaar.

———. *Jasper Johns: Working Proofs*, exhibition catalog. Basel: Kunstmuseum Basel, 1979. Includes interview by Christian Geelhaar.

Goldman, Judith. Introduction to *Foirades/Fizzles*, exhibition catalog. New York: Whitney Museum of American Art, 1977. Five prose fragments by Samuel Beckett and thirty-three etchings by Jasper Johns.

———. *Jasper Johns: Prints 1977–1981*, exhibition catalog. Boston: Thomas Segal Gallery, 1981.

Hopkins, Henry. Preface to *Jasper Johns: Figures 0 to 9*. Los Angeles: Gemini G.E.L., 1968. Catalog of the prints.

Hopps, Walter. *Jasper Johns: Fragments—According to What*. Los Angeles: Gemini G.E.L., 1971. Catalog of the prints.

Huber, Carlo. *Jasper Johns Graphik*, exhibition catalog. Bern: Verlag Kornfeld und Klipstein, 1970. Published on occasion of traveling exhibition.

———. Preface to *Opera grafica di Jasper Johns*, exhibition catalog. Milan: Castello Sforzesco, 1972.

Jasper Johns: Drawings, exhibition catalog. Tokyo: Minami Gallery, 1975.

Jasper Johns: Drawings and Prints 1975–1979, exhibition catalog. Houston: Janie C. Lee Gallery, 1979.

Jasper Johns: Lithographs 1973–1975. Los Angeles: Gemini G.E.L., 1975. Catalog of the prints.

Jasper Johns Litografii, exhibition catalog. Bucharest: Ateneul Roman, 1970.

Jasper Johns: Seventeen Monotypes. West Islip, N.Y.: U.L.A.E., 1982.

Kozloff, Max. *Jasper Johns*. New York: Harry N. Abrams, 1968.

———. *Jasper Johns*. New York: Harry N. Abrams, 1974.

Leeper, John Palmer. Preface to *Jasper Johns: The Graphic Work*, exhibition catalog. San Antonio: Marion Koogler McNay Art Institute, 1969.

Munsing, Stefan. Preface to *The Drawings of Jasper Johns*, exhibition catalog. Washington, D.C.: National Collection of Fine Arts, 1966.

Robertson, Bryan. *Jasper Johns*, exhibition catalog. London: Hayward Gallery, 1978.

Rose, Barbara. Preface to *Jasper Johns: 6 Lithographs (After "Untitled 1975")* 1976. Los Angeles: Gemini G.E.L., 1976. Catalog of the prints.

Rosenblum, Robert. Preface to *Jasper Johns 1955–1960*, exhibition catalog. Columbia, S.C.: Columbia Museum of Art, 1960.

Solomon, Alan R. *Jasper Johns*, exhibition catalog. New York: Jewish Museum, 1964. Includes essay by John Cage, "Jasper Johns: Stories and Ideas."

———. Preface to *Jasper Johns Lead Reliefs*. Los Angeles: Gemini G.E.L., 1969. Catalog of the prints.

———. *Jasper Johns: Paintings, Drawings, and Sculpture, 1954–1964*, exhibition catalog. London: Whitechapel Gallery, 1964. Includes reprints of essays by John Cage and Alan R. Solomon first published by the Jewish Museum.

Stanislawski, Ryszard. *Jasper Johns litografie*, exhibition catalog. Lodz: Museum Sztuki w Lodzi, 1970.

Sylvester, David. *Jasper Johns Drawings*, exhibition catalog. London: Arts Council of Great Britain, 1974. Includes interview by David Sylvester.

Tono, Yoshiaki. *Jasper Johns*, exhibition catalog. Tokyo: Minami Gallery, 1965.

Periodicals, Books, and Group-Exhibition Catalogs

Alloway, Lawrence. "Jasper Johns and Robert Rauschenberg." In *Figurative Art since 1945*, London: Thames and Hudson, 1971, pp. 201–16. Revised and reprinted in *American Pop Art*, exhibition catalog. New York: Collier Books and Whitney Museum of American Art, 1974, pp. 52–75.

Ashbery, John. "Brooms and Prisms." *Artnews* 65 (March 1966): 58–59. Review of exhibition at Leo Castelli Gallery, New York.

Bernstein, Roberta. "Jasper Johns and the Figure: Part One: Body Imprints." *Arts Magazine* 52 (October 1977): 142–44.

Cage, John. "Jasper Johns: Stories and Ideas." *Art and Artists* 3 (May 1968): 36–41. Excerpt from *A Year from Monday: Lectures and Writings by John Cage*. London: Calder and Boyars, 1967. American edition, Middletown, Conn.: Wesleyan University Press, 1969, pp. 73–84.

Calas, Nicolas. "Jasper Johns: And/Or." In *Icons and Images of the Sixties*. New York: E. P. Dutton, 1971, pp. 72–82.

———. "Jasper Johns ou: 'ceci n'est pas un drapeau.'" *XXe Siècle*, n.s. 50 (June 1978): 33–39.

Canaday, John. "Art: New Paintings from Jasper Johns." *New York Times*, March 2, 1968, p. 25. Review of exhibition at Leo Castelli Gallery.

———. "Incidentally about Jasper Johns." *New York Times*, January 3, 1971, sec. D, p. 19. Review of exhibition at the Museum of Modern Art.

Carpenter, Joan. "The Infra-iconography of Jasper Johns." *Art Journal* 36 (Spring 1977): 221–27.

Davis, Douglas. "Currier to Ives to Johns." *Newsweek* 82 (September 3, 1973): 60–63. Includes statements.

Feinstein, Roni. "New Thoughts for Jasper Johns' Sculpture." *Arts Magazine* 54 (April 1980): 139–45.

———. "Jasper Johns *Untitled* (1972) and Marcel Duchamp's Bride." *Arts Magazine* 57 (September 1982): 86–93.

Field, Richard S. "Jasper Johns' Flags." *Print Collector's Newsletter* 7 (July–August 1976): 69–77.

Frackman, Noel. "Jasper Johns: Prints." *Arts Magazine* 52 (January 1978): 21. Review of exhibition at Leo Castelli Graphics.

Fried, Michael. "New York Letter." *Art International* 7 (February 25, 1963): 60–62. Review of exhibition at Leo Castelli Gallery.

Gablik, Suzi. "Jasper Johns's Pictures of the World." *Art in America* 66 (January 1978): 62–69.

Geldzahler, Henry. "Numbers in Time: Two American Paintings." *Metropolitan Museum of Art Bulletin* 23 (April 1965): 295–99.

Glueck, Grace. "'Once Established,' Says Jasper Johns, 'Ideas Can Be Discarded.'" *New York Times*, October 16, 1977, sec. 2, pp. 1, 31. Review, based on an interview, of exhibition at the Whitney Museum of American Art.

———. "Painting by Jasper Johns Sold for Million, a Record." *New York Times*, September 27, 1980, pp. 1, 12.

Greenberg, Clement. "After Abstract Expressionism." *Art International* 6 (October 25, 1962): 24–32. Revised and reprinted in Henry Geldzahler, *New York Painting and Sculpture: 1940–1970*, New York: E. P. Dutton and Metropolitan Museum of Art, 1969, pp. 360–71.

Harrison, Charles, and Orton, Fred. "Jasper Johns: 'Meaning What You See.'" *Art History* 7 (March 1984): 77–101.

Heller, Ben. "Jasper Johns." In B. H. Friedman, ed., *School of New York: Some Younger Artists.* New York: Grove Press, 1959, pp. 30–35.

Herrman, Rolf-Dieter. "Johns the Pessimist." *Artforum* 16 (October 1977): 26–33. "Correction." *Artforum* 16 (December 1977): 12.

———. "Jasper Johns' Ambiguity: Exploring the Hermeneutical Implications." *Arts Magazine* 52 (November 1977): 124–29.

Hess, Thomas B. "On the Scent of Jasper Johns." *New York Magazine* 9 (February 9, 1976): 65–67.

———. "Jasper Johns: Tell a Vision." *New York Magazine* 10 (November 7, 1977): 109–11. Review of exhibition at the Whitney Museum of American Art.

Higginson, Peter. "Jasper's Non-Dilemma: A Wittgensteinian Approach." *New Lugano Review* 10 (1976): 53–60.

"His Heart Belongs to Dada." *Time* 73 (May 4, 1959): 58. Includes statements.

Hobhouse, Janet. "Jasper Johns: The Passionless Subject Passionately Painted." *Artnews* 76 (December 1977): 46–49.

Hughes, Robert. "Art: Pictures at an Inhibition: Jasper Johns' New York Retrospective." *Time* 110 (October 31, 1977): 84–86. Includes statements.

Important Contemporary Prints. New York: Sotheby Parke Bernet, February 7, 1975. Sale 3724, lots 21–45.

"Jasper Johns' Eyeful of Foolery: Oh, Say Can You See?" *Time*, January 14, 1966, pp. 70–71.

Johnson, Ellen H. "Jim Dine and Jasper Johns: Art about Art." *Art and Literature* 6 (Autumn 1965): 128–40. Reprinted in Ellen H. Johnson, *Modern Art and the Object*, New York: Harper and Row, 1976, pp. 171–76.

Kaplan, Patricia. "On Jasper Johns' *According to What.*" *Art Journal* 35 (Spring 1976): 247–50.

Kozloff, Max. "Art." *Nation,* March 16, 1964, pp. 274–76. Reprinted as "Jasper Johns," in *Renderings: Critical Essays on a Century of Modern Art*, New York: Simon and Schuster, 1968, pp. 206–11. Review of exhibition at the Jewish Museum.

———. "Johns and Duchamp." *Art International* 8 (March 1964): 43–45.

———. "Jasper Johns: The 'Colors,' the 'Maps,' the 'Devices.'" *Artforum* 6 (November 1967): 26–31.

Kramer, Hilton. "Month in Review." *Arts Magazine* 33 (February 1959): 48–51. See p. 49. Review of exhibition *Beyond Painting* at Alan Gallery, New York.

———. "Johns's Work Doesn't Match His Fame." *New York Times*, December 18, 1977, sec. D, p. 33.

Krauss, Rosalind. "Jasper Johns." *Lugano Review* 1 (1965): 84–113.

———. "Jasper Johns: The Functions of Irony." *October* 2 (Summer 1976): 91–99.

Kuspit, Donald B. "Personal Signs: Jasper Johns." *Art in America* 69 (Summer 1981): 111–13. On the occasion of an exhibition of drawings at Leo Castelli Gallery.

Masheck, Joseph. "Jasper Johns Returns." *Art in America* 64 (March–April 1976): 65–67.

Michelson, Annette. "The Imaginary Object: Recent Prints by Jasper Johns." *Artist's Proof* 8 (1968): 44–49.

Perrone, Jeff. "Jasper Johns's New Paintings." *Artforum* 14 (April 1976): 48–51.

———. "Purloined Image." *Arts Magazine* 53 (April 1979): 135–39.

Porter, Fairfield. "The Education of Jasper Johns." *Artnews* 62 (February 1964): 45, 61–62.

Ratcliff, Carter. "The Inscrutable Jasper Johns." *Vanity Fair* 47 (February 1984): 60–64.

Restany, Pierre. "Jasper Johns and the Metaphysic of the Common Place." *Cimaise* 8 (Sep-

120. *Canvas*, 1956
Encaustic and collage on canvas with objects,
30 x 25 in.
Private collection

tember–October 1961): 90–97. Text also printed in French, German, and Spanish.

Rose, Barbara. "The Graphic Work of Jasper Johns: Part 1." *Artforum* 8 (March 1970): 39–45. "Part 2." *Artforum* 8 (September 1970): 65–74.

———. "Decoys and Doubles: Jasper Johns and the Modernist Mind." *Arts Magazine* 50 (May 1976): 68–73.

———. "Jasper Johns: Pictures and Concepts." *Arts Magazine* 52 (November 1977): 148–53.

———. "To Know Jasper Johns." *Vogue* 167 (November 1977): 280–85.

———. "Modern Classics: Johns and Balthus." *Vogue* 174 (February 1984): 362–65, 417–18.

Rosenberg, Harold. "The Art World: Twenty Years of Jasper Johns." *New Yorker* 53 (December 26, 1977): 42–45.

———. "Jasper Johns: Things the Mind Already Knows." *Vogue* 143 (February 1964): 175–77, 201–3. Reprinted in Harold Rosenberg, *The Anxious Object*, New York: Collier Books, 1973, pp. 176–84.

Rosenblum, Robert. "Jasper Johns." *Art International* 4 (September 25, 1960): 75–77.

———. "Les Oeuvres récentes de Jasper Johns." *XXe Siècle*, n.s. 18 (February 1962), unpaginated supplement.

Rubin, William. "Younger American Painters." *Art International* 4, no.1 (1960): 24–31.

Russell, John. "Jasper Johns." *Connaissance des Arts* 223 (July 1971): 48–53.

———. "Jasper Johns and the Readymade Image." In *Meanings of Modern Art*, vol. 11. New York: Museum of Modern Art, 1975, pp. 15–23.

———. "Jasper Johns Stretches Himself and Us." *New York Times*, February 1, 1976, sec. D, p. 31–32.

———. "Jasper Johns Packs Them In." *New York Times*, October 21, 1977, sec. C, p. 21. Review of exhibition at the Whitney Museum of American Art. Reprinted in *Visual Dialog* 4 (Fall 1978): 18–20.

———. "The Provocative Drawings of Jasper Johns." *New York Times*, January 25, 1981, sec. D, p. 25.

———. "Art: Jasper Johns Show Is Painter at His Best." *New York Times*, February 3, 1984, sec. C, p. 22.

Sandler, Irving. "In the Art Galleries." *New York Post*, March 1, 1964, magazine, p. 14. Review of exhibition at the Jewish Museum.

A Selection of Fifty Works from the Collection of Robert C. Scull. New York: Sotheby Parke Bernet, October 18, 1973. Sale 3558, lots 14–19.

Shapiro, David. "Imago Mundi." *Artnews* 70 (October 1971): 40–41, 66–68. On Jasper Johns's *Map*.

Shestack, Alan. "Jasper Johns: Reflections." *Print Collector's Newsletter* 8 (January–February 1978): 172–74.

"Starring Jasper Johns." *Print Collector's Newsletter* 12 (January–February 1982): 178. Announcement of a film by Katrina Martin.

Steinberg, Leo. "Contemporary Art and the Plight of Its Public." *Harper's Magazine* 224 (March 1962): 31–39. Reprinted in Gregory Battcock, ed., *The New Art: A Critical Anthology*, New York: E. P. Dutton, 1966, pp. 27–47, and in Leo Steinberg, *Other Criteria: Confrontations with Twentieth Century Art*, New York: Oxford University Press, 1972, pp. 3–16.

———. "Jasper Johns." *Metro* 4–5 (May 1962). Revised for *Jasper Johns*, New York: Wittenborn, 1963. Revised as "Jasper Johns: The First Seven Years of His Art," in *Other Criteria*, pp. 17–54.

Tillim, Sidney. "Ten Years of Jasper Johns." *Arts Magazine* 38 (April 1964): 22–26.

Tomkins, Calvin. *Off the Wall: Robert Rauschenberg and the Art World of Our Time.* New York: Doubleday, 1980.

"Trend to the "Anti-Art": Targets and Flags." *Newsweek* 51 (March 31, 1958): 94–96. Review of exhibition at Leo Castelli Gallery. Includes statements.

Young, Joseph E. "Jasper Johns: An Appraisal." *Art International* 13 (September 1969): 50–56.

121. *Flag*, 1960
Sculpmetal and collage on canvas,
12½ x 19 in.
Robert Rauschenberg

Index

Photography Credits

All photographic material was obtained directly from the collection or photographer indicated in the caption, except for the following: Joachim Blauel: plate 98; Courtesy Blum Helman Gallery, New York: plate 50; Rudolph Burckhardt, New York: plates 21, 23, 33, 44, 50, 52, 60, 120, 121; Rudolph Burckhardt, courtesy Leo Castelli Gallery, New York: plates 29, 35, 36, 42, 53, 59, 86; Courtesy Leo Castelli Gallery, New York: cover, frontispiece, plates 14, 15, 18, 31, 41, 45, 48, 55, 67, 69, 70, 84, 89, 97, 101, 110, 116; Geoffrey Clements, New York: plates 16, 19; Bevan Davies, New York: plate 99; Bevan Davies, courtesy Leo Castelli Gallery, New York: plates 103, 118; Michael G. Fischer, courtesy National Museum of American Art, Smithsonian Institution, Washington, D.C.: plate 58; Hans Hinz, courtesy Kunstmuseum Basel: plates 2, 17, 83; Jones-Gessling Studio, courtesy Leo Castelli Gallery, New York: plate 25; Bruce C. Jones: plate 28; Eric Mitchell, Philadelphia: plates 1, 30; Eric Pollitzer, New York: plates 10, 34, 37, 39, 63, 65, 68, 72, 76, 80, 81, 91, 95; Eric Pollitzer, courtesy Leo Castelli Gallery, New York: plates 61, 62, 92–94; Marc Schuman, Glenwood Springs, Colorado: plate 26; Glen Steigelman, courtesy Leo Castelli Gallery, New York: plates 106, 109; Joseph Szaszfai: plate 75; Frank Thomas, Los Angeles: plate 96; Charles Uht: plate 40; Copyright Untitled Press, Inc.: plate 11; Malcolm Varon, New York: plate 9; Dorothy Zeidman, New York: plate 112; Dorothy Zeidman, courtesy Leo Castelli Gallery, New York: plates 6, 108; Zindman/Fremont, courtesy Leo Castelli Gallery, New York: plate 104.

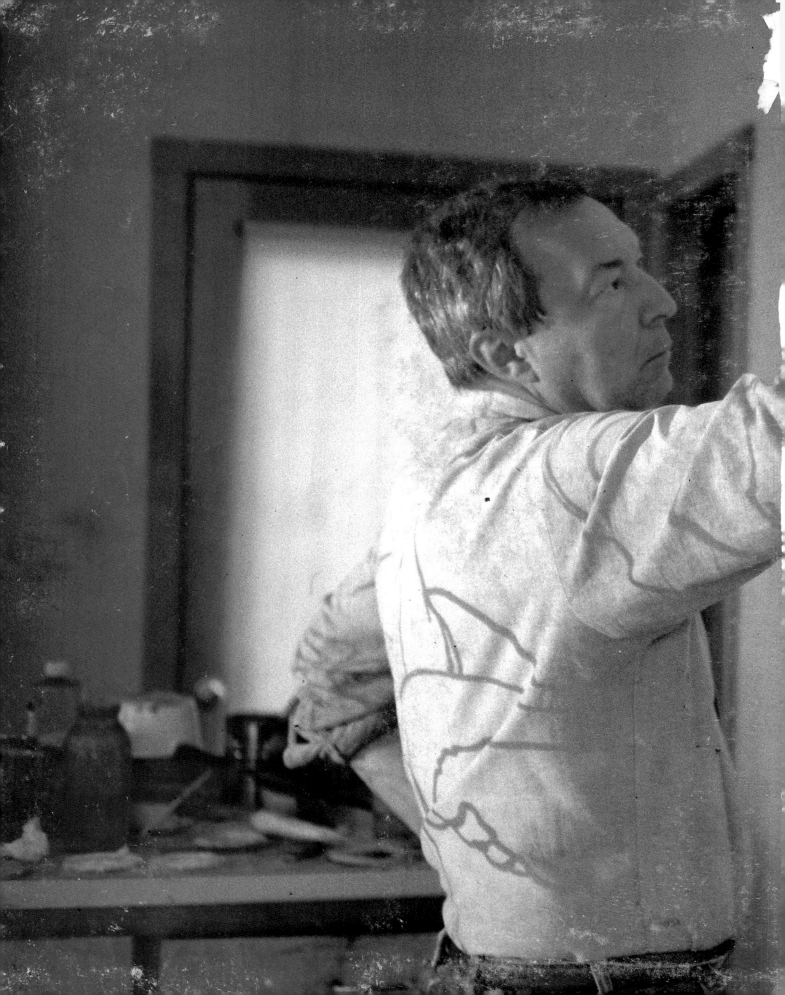